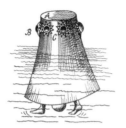

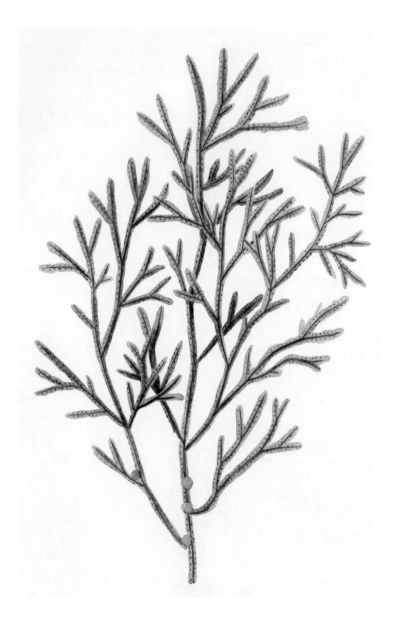

Seaweed

An Enchanting Miscellany

Miek Zwamborn

Translated from the Dutch
by Michele Hutchison

GREYSTONE BOOKS

Vancouver/Berkeley

Greystone Books Ltd.
greystonebooks.com

Cataloguing data available from Library and Archives Canada
ISBN 978-1-77164-599-7 (cloth)
ISBN 978-1-77164-600-0 (epub)

Cover design by Fiona Siu
Interior design by Henry Iles
Cover illustrations by Falk Nordmann and Miek Zwamborn

Printed and bound in China on ancient-forest-friendly paper by 1010 Printing Asia Ltd.

Greystone Books gratefully acknowledges the Musqueam, Squamish, and
Tsleil-Waututh peoples on whose land our office is located.

Greystone Books thanks the Canada Council for the Arts, the British Columbia Arts
Council, the Province of British Columbia through the Book Publishing Tax Credit,
and the Government of Canada for supporting our publishing activities.

This publication has been made possible with financial support from the
Dutch Foundation for Literature.

Images on preceding pages:
Diving bell invented by Franz Keßler, around 1600.
Fucus vesiculosus from Hydrophytologiae Regni Neapolitani icones, Neapoli 1829.

At first I saw everything from below,
and then I was algae.

MONIKA RINCK

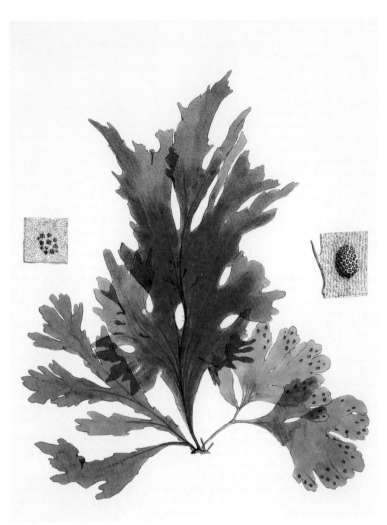

The fronds of Nitophyllum smithii rise up like a blazing fire. Joseph Dalton Hooker picked this specimen during his Arctic expedition in 1842 in the icy sea around the Falkland Islands from the holdfast of a larger seaweed.

Contents

I

Underwater Forests

WALKING TO THE SCOTTISH TIDAL ISLAND of Erraid at ebbtide, I came across an immense chunk of seaweed beached in the bay. Its dark leaves and stems contrasted strongly with the pale sand. The seaweed looked lively and spiralled like an Archimedean screw. The outgoing tide had tugged the leaves open wide. A sturdy stem emerged from a large gold-studded ball; not round but flat and wide, bordered with amber-coloured ruffles. The stem became smoother as it progressed and ended in a leathery leaf that was split into 21 long, ragged strips, each pointing in a different direction. My gaze slid back along the milled edges of the stem. The seaweed plant shone as though it had been polished and seemed to be filled with a strange force. It appeared boundless. Although torn from its colony and washed ashore, it showed no signs of decay. I knelt down and ran my fingers through the strands. The stalk and leaves felt firm and were cooler than I expected.

Of course I had seen seaweed before, at home growing up in the Netherlands. I had slithered over it to reach the mudflats beyond the dyke. I had folded it back over rocks to fish for shrimp and covered my oysters with it after collecting them in a bucket. It sometimes wrapped itself around your legs in the sea. Yet I had never really looked

With its flamboyant ruffles along the thallus, Saccorhiza polyschides *is one of the most sensuous seaweeds.*

at it properly. The mysterious appearance of this specimen, which had grown under water into such a coquettish beauty, changed that. I am not exaggerating when I say that it brought about an immense shift in my experience of the coast. The sea had opened up to me that day and, before the tide turned, I'd been allowed my first peek inside.

I carefully slid my hands under the heavy stem and stood up. The weed heeled over, forming a parabola. I slung it over my shoulder. It was twice my height. Folded double it touched the rippled sand on both sides: a vertical embrace. Zigzagging around the bronze-green bladderwrack that covered the rocks in the bay, I headed across the mudflats to Erraid. When I looked back at the beach where I had come from, I saw a winding line next to my footprints. The ends of the leaves were heavy enough to trace our route in the sand.

Perhaps it was because, in my work as an artist, I had been compiling the absolute opposite for a while: a herbarium, a collection of mounted dried plants, in which the green foliage was brittle, pale and motionless, affixed to the page with tiny stitches. This clump of seaweed, on the other hand, was brimming with life. It excelled in elasticity and tenacity. The robust texture and baroque elegance lent it something alien. How could the cells of a simple organism grow into such exuberantly complex matter? The discovery of the seaweed giant sparked in me an urge to explore the sea's depths.

I had brought seaweed onto dry land, an individual specimen that had reached a respectable size on its own. In the days that followed I collected nothing but seaweed: green, red and brown varieties and all the colours that lie between them; and spotted, perforated, translucent, albino. I cut it loose from the rocks, plucked it from the surf or picked it up along the tideline. I submerged shrivelled seaweed under water until it unfolded and revived like roses of Jericho. This was how it began.

Seaweed is the collective name for marine algae, which divide into
MACROALGAE and MICROALGAE. Macroalgae are the most flexible,
resilient and fertile plant species on Earth. They can survive on the
rugged and turbulent coastlines of the most unstable environments
and can be found in all climate zones, from the tropics to the poles.
There are around 10,000 different species, some of which survive in
extremely harsh conditions, enduring storms, penetrating sunlight,
acidification and drying out at low tide. Fossil records indicate that
seaweeds have been in existence for 1.7 billion years. They seem to
have evolved little in all this time.

Within the plant kingdom, algae are classified as 'lower plants'.
They have no structures that characterize the more sophisticated,
higher plant types: no roots, stems, leaves or conductive tissue. Each
individual cell within a seaweed plant is able to provide for itself,
independently of the other cells in the plant.

Seaweeds nourish themselves by photosynthesis. Like the higher
plants, they contain chlorophyll, but the pigments that absorb the
sunlight are variable. Seaweeds can be green, but also red, brown,
yellow or orange, due to the fact that the green pigment can be
'masked' by other pigments.

Most seaweed can be subdivided into six main groups based on
colour, structure and lifecycle.

GREEN SEAWEEDS are single or multi-celled green-coloured algae.
The single-celled species often have two whip-like strands (flagella)
of the same length, anchored in the cell body, which allow them to
propel themselves through the water. Multi-cellular species can take
the most varied forms. Green algae have the same type of chlorophyll
as land plants. Green algae are mainly found in fresh water. However,

Many weeds grow as epiphytes on other algae and flutter loosely in the current.

some also thrive in salt water. It is assumed that they share common ancestors and that land plants evolved from green algae.

RED SEAWEEDS are multi-cellular red-coloured algae, but there are also single-celled types. They mainly live in the sea, but some species occur in fresh water or on land. They are usually branched, some have leaf-like fronds, others have chalky crusts. Chalky red seaweed stores calcium deposits and, as a result, makes an important contribution to the formation and stabilization of coral reefs.

BROWN SEAWEEDS are multi-celled, brown-coloured algae with a complex construction. They are often branched, with leaf- and stem-shaped structures. Brown algae are almost exclusively found in the sea. This group includes the largest and fastest-growing seaweeds on Earth, such as the giant kelp, which grows into immense kelp forests.

DIATOMS are distant relatives of the brown algae. They are yellowish-brown-coloured microalgae, ranging in size from ten to a hudnred micrometres, and have a silicon dioxide exoskeleton. As the main component of phytoplankton, these single-celled organisms provide approximately half of the combined biomass in the sea and produce most of the oxygen present in the atmosphere.

Another group of tiny microalgae, DYNOFLAGELLATES are what cause the lights or 'red tide' in the sea, by means of bioluminescence. These microscopic plankton occur in all kinds of shapes in salt and fresh water and are often covered with spines. Some dynoflagellates produce a survival capsule, in which they bide their time until circumstances become more favourable for reproduction. They simply sink to the bottom of the sea in their capsules and wait.

BLUE-GREEN ALGAE, despite their name, are not true algae and are not related to the other types of seaweed but rather a type of bacteria

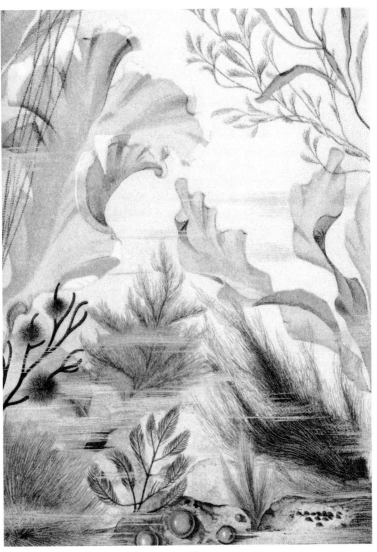

A semi-transparent filigrane underwater amphitheatre. Depicting water is one of the most difficult challenges for artists.

(and like other bacteria have no cell nucleus). They were formerly classified as seaweed or algae because they are similar in size to microscopic algae and share their habitat. These days they are classified as 'cyanobacteria'. Their cells are often surrounded by a mucus layer in which calcite from seawater can be stored. Because of this property, they are responsible for special rock formations that occur over time called 'stromatolites'.

Finally, there is a microalgae group comprising HAPTOPHYTA and CRYPTOMONADS, with a size of less than 20 µm. These play a major role in the oceans as the primary producer of phytoplankton.

Seaweeds do well in both calm and turbulent water. The coast can be divided into three different zones. The area that is only sprayed by the surf and isn't submerged by a normal high tide is called the splash zone. Only spring floods and storm floods flood this zone. All organisms that live in it are resistant to dehydration. The adjacent area is completely submerged by a normal high tide, but stays dry at normal ebb. This zone between the high and low waterline is also called the tidal zone. The third, the sublittoral zone, lies below the average low-water line. The seaweed that grows in this band always remains fully under water.

Seaweed always needs a hard substrate to grow upon. Where this lacking in nature it will settle on dykes, breakwaters and piers. Sandy coasts are unsuitable for the development of algae. The sand moves too much and therefore offers no support. Only on mudflats with low currents can species such as sea lettuce and *Ulva linza* flourish.

Not all fixed seaweed is indigenous: seaweeds can be torn from their substrata by strong winds or ice. Sometimes they continue to

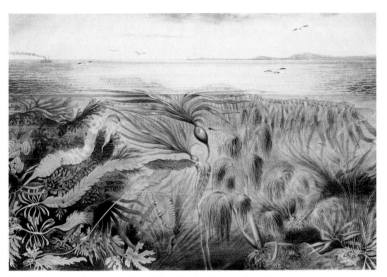

The kelp forest in the ocean is flanked by a lively selection of smaller algae.

grow elsewhere. Japanese wireweed (*Sargassum muticum*) is a species that was accidentally imported to Western Europe from Japan in the 1970s, attached to oysters, and is now considered invasive.

Many algae that wash ashore have broken free from far-off coasts. They do not respect national borders. Depending on the current, they float towards land. Sometimes they travel for weeks. You could try to calculate where they originated from with a river atlas, a map of the seabed and weather reports, but it would remain guesswork.

Hundreds of hands waving in the current. They wave to the coast and to themselves day in, day out, on long slender wrists; underwater rounds of applause. The palms of oarweed (*Laminaria digitata*) are many times more agile than the hands they remind me of: the ochre

handprints on the walls of the Leang Timpuseng cave on Sulawesi
in Indonesia, made about 39,000 years ago. The handprints reveal
how important the creative process has been for humankind right
from the outset. On October 9 2014, the *Guardian* reported that new
research reveals that the Flores people, who died out some 50,000
years ago, already had imaginative and pictorial skills and that, in
addition to hunting and gathering, portraying their environment, the
animals around them, and themselves, was key to survival. This does
not only apply to Asia, but also to Africa and Europe.

We'll never find out when seaweed was depicted for the first time but
it must have been part of the human diet from the beginning, and used
for its medical properties and perhaps also even as a mode of transport.
A theory which was recently tested out on a BBC programme is that
seaweed was used by Neolithic people on the Orkney Islands to slide
giant stones from the sea to build their circles and henges.

One of the thousands of seaweed hands along the south coast of Mull
was torn off in a storm and floated endlessly on the current, past
underwater chasms and dangerous cliffs. The hand entered calmer
waters and was rocked back and forth for hours by the waves. After
countless gyrations, the long wrist with its waving hand rolled onto
land, cutting against the waves. At low tide, a wall of battered hands,
gathered by the ocean, had been built on Ardalanish beach. One
undamaged hand remained spread wide atop the ripples of sand,
waving at the sky and the dune ridge.

In the summer of 2015, I spent two weeks holidaying on the Isle of
Erraid. From the first moment on, it felt like a place where I belonged.
Perhaps it had something to do with the historic lighthouse buildings.

I was a former bridge- and lockkeeper in possession of a lighthouse diploma. Halfway through the nineteenth century, lighthouses had been built from granite quarried from the island. The dangerous sea around the Inner and Outer Hebrides, where so many ships have run aground, was finally navigable for the first time in centuries.

There was a house, Knockvologan, on the other side of the bay that needed new occupants to take care of the nature reserve of Tireragan at its back door. I moved in one year later. A career as a lighthouse keeper, which I'd always dreamed of, seemed more unlikely than ever. The closest lighthouses, Dubh Artach and Skerryvore, were automated years earlier. No matter: the surroundings turned out to be inspiring as a place to write about and to further my visual work as an artist.

Without the vast wind-carved landscape around Knockvologan, with its remote sandy beaches, the many small islands off the coast, the changing seas and swampy peat bogs, that knot of seaweed would probably never have caught my eye, and the work of the people described in this book would have remained unknown to me. They have all come in close contact with seaweed, whether as astronauts, farmers, chefs, filmmakers, photographers, graphic artists, musicians, painters, survivors of shipwrecks, writers, spinners, beachcombers, textile designers, sorcerer's apprentices, scientists or sailors.

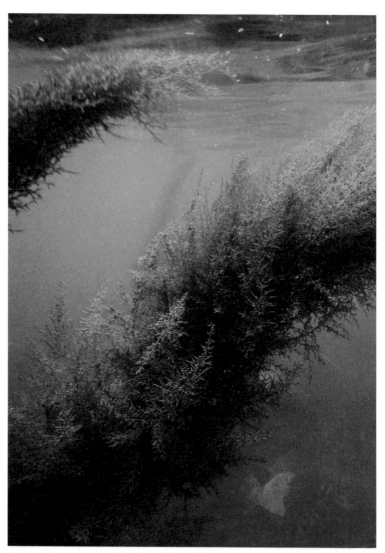

Invasive Sargassum around the Scottish Isle of Mull.

2

Wide Sargasso Sea

SARGASSUM IS A GOLDEN ALGAE that floats on the surface in large clumps as well as forming 'Sargasso forests' along the coasts. The free-floating patchwork quilts of seaweed are kept afloat by their abundant air sacks and can survive in the strongest currents. They offer a home to many species of marine life, many of which are not found anywhere else on the planet. When the sun shines on the brown algae's bladders, they look like white gooseberries.

The Sargasso Sea is named after this characteristic brown seaweed. Bordered on the west by the Gulf Stream, on the north by the North Atlantic Current, on the east by the Canary Current and on the south by the North Atlantic Equatorial Current, it is the only ocean in the world without a coastline: a sea between seas. Over recent years, due to climate change, the rootless *Sargassum* has started to cause a seaweed bloom that could become dangerous. Coral reefs and seagrass ecosystems suffer when high levels of *Sargassum* change water chemistry and block organisms from moving freely.

Massive clumps of seaweed have been troublesome before. On September 16 1492, Christopher Columbus got caught in it on his way from the Canary Islands to the Bahamas with his ships *Niña*,

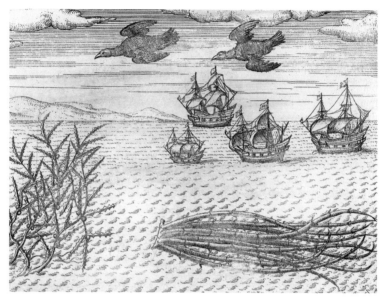

The ultimate holdup for sailors: getting stuck in the never-ending Sargassum *around Cape of Good Hope. These birds and ships are circumnavigating the problem.*

Pinta and Santa Maria. In his ship's log, he describes how he and his crew struggled with the seaweed.

> SEPTEMBER 16 – *'We have begun to see large patches of yellowish green weed, which seems to have been torn away from some island or reef. I know better because I make the mainland to be further on.'*

> SEPTEMBER 17 – *'I saw a great deal of weed today from rocks that lie to the west. I take this to mean we are near land. The weed resembles a grass except that it has long stalks and shoots and is loaded with fruit like the mastic tree.'*

THURSDAY 20 SEPTEMBER 1492 – *'Today I changed course for the first time since leaving Gomera because the wind was variable and sometimes dropped. We sailed north-west and then west-northwest … The men caught a small fish…'*

'And we saw much weed of the kind I have already mentioned, even more than before, stretching to the north as far as you can see. In a way this weed comforted the men, since they concluded it must have come from some nearby land. But at the same time, it caused some of them great apprehension because in some places it was so thick it actually held back the ships. Since fear evokes imaginary terrors, the men thought that the weed might become so thick and matted that there might happen to them what is supposed to have happened to St. Amador when he was trapped in a frozen sea that held his ship fast. For these reasons we kept as clear as possible from these mats of weed.'

WEDNESDAY 3 OCTOBER 1492 – *'There is more weed, but it is withered and appears old. There is a little fresh weed that bears something like fruit.'*[1]

Earlier in history, sailors had already reported extensive, unmanageable amounts of *Sargassum* and similar entanglements. In twelfth-century scholarly texts written by Western Europeans, frequent mention was made of the dangerous *lever zee*, also referred to as the *mare coagulatum* or 'curdled sea'. Finding oneself in the curdled sea was one of the greatest fears of seafarers in the Middle Ages. Algae would wrap themselves around the rudder, rendering ships unsteerable and uncontrollably adrift. Most captains avoided the sea even though they did not know its exact location.

The Greek geographer and historian Strabo (c. 63 BC–c. AD 24) quotes Pytheas of Marseilles, who allegedly said:

In the northern area is neither land, nor water, nor air, but a mixture of these, similar to a marine lung in which land and sea and all things are suspended, and this mixture is as if it were a fetter of the whole existing in a form impassable by foot or ship: an immobile sea.[2]

In his fourth-century poem *Ora Maritima*, Rufius Festus Avienus describes a congealed sea in which the Carthaginian explorer Himilco gets stuck, around 525 BC, on a journey through the Atlantic Ocean. It took Himilco four months to get out again:

No breezes propel a craft, the sluggish liquid of the lazy sea is so at a standstill. He also adds this: A lot of seaweed floats in the water and often after the manner of a thicket holds the prow back. He says that here nonetheless the depth of the water does not extend much and the bottom is barely covered over with a little water. They always meet here and there monsters of the deep and beasts swim amid the slow and sluggishly crawling ships. Mist envelops sky and the surface of the sea like a cloak and the clouds are motionless in the thick sky.[3]

'The sea crept stealthily forwards and backwards,' wrote Dominica-born British author Jean Rhys in her revisionist novel *Wide Sargasso Sea* (1966).[4] She chose the shoreless sea as a metaphor for the agitation, isolation and restlessness of her protagonist Antoinette Cosway, who you may have met before in Charlotte Brontë's *Jane Eyre* (1847) as Bertha Mason.

Just as the new generation develops along the leaf edges of many seaweed types, Rhys plants and feeds her imaginative intertextual response to her predecessor's main character, reshaping the characters

and plot of the Victorian masterpiece. Antoinette feels rootless, and becomes totally entangled in her marriage to a sadistic husband who suffocates her. In her prequel, Rhys settles accounts with Brontë, who had completely silenced the unfortunate creole woman Bertha. By giving a Caribbean voice to a marginalized character and creating other perspectives, she contributed to a more complete history and transformed her original tragic demise into a triumphant heroism.

Let us turn to a great scientist who actually crossed the Sargasso Sea. German naturalist and explorer Alexander von Humboldt mapped the long windrow-like concentrations of *Sargassum* as he found them during his voyage to the Americas between 1799 and 1804. He wrote:

There lies the Sargasso Sea, that large bank of Fucus *weed, which so appealed to Christopher Columbus's imagination and which Ovid called the 'weed meadows' (*praderias de yerva*). Numerous tiny marine creatures inhabit these perennially green masses of* Fucus natans, *moved back and forth by lukewarm winds…5*

It certainly is a bustling place. Beneath the *Sargassum* lie the most important breeding grounds for European and American eels. They lay their eggs in the shelter of the weed and, when they hatch, the young glass eels migrate to Europe. When, after several years, they finally reach sexual maturity, they return to the far-off Sargasso Sea to spawn in the depths and to die.

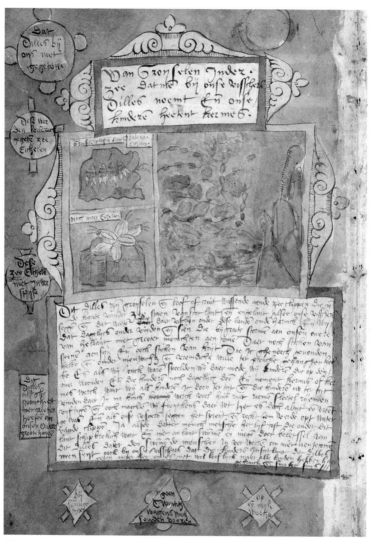

The sixteenth-century Dutch fishmonger Adriaan Coenen presented descriptions and paintings of his beach finds enclosed by marquetry-like frames.

3

Tidelines

AND NOW AN IMPORTANT FIGURE appears on the sea stage. He spent his life onshore but knew all about the sea's riches: Adriaan Coenen, a beachcomber from Scheveningen, wholesaler in fish and fish auctioneer. Coenen was born in 1514 and, over the course of his life, produced at least four album portfolios dedicated to whales, marine mammals, fish and other creatures that lived in the seas of Europe.

Three of these illustrated albums have been preserved in their original state: *Visboeck*, *Walvisboeck* and *Haringkoningboeck*. They were never published, but right from the start were considered valuable. Coenen's aquarelles, now faded considerably, were beautifully colourful. He always united the sea creature and its description in a decorative frame, as though to say: 'What you see and read here belongs together forever'. The texts are descriptive and honest. Coenen had never even seen some of the natural phenomena he describes and he admits this in his captions.

He wrote of the strange plants growing on rock and reefs in the sea:

Our fishermen call these beach feathers and catch them in the herring nets. They stick these beach feathers in their hats and when the feathers dry out, they dip them back in the water so that they open up again.

The caption to the following picture reads:

> *These fingers and thumbs, as our fishermen call them, cannot be distinguished from real human hands, except then in colour and because they are plump with moisture. Our fishermen catch them on hooks from a rocky seabed.*

Later in the book, he writes about grapes and dill, by which he probably means bladderwrack:

> *I do not know what kind of plant these grapes can be. I have found them growing on oysters, and usually their berries are dry and empty. I have found some that were as large as two human heads, but also as one human head or smaller ... Dill is a plant or herb that grows on the English cliffs, our fishermen who fish for herring along the coast there have told me. After severe storms, large quantities of this dill end up on the Dutch beaches. Yes, on certain occasions you could load a hundred wagons with the dill along a mile of the coast. When I was young us kids played with it and called it kermes* [freak show], *because it had such strange growths. We made whistles, key cords, and belts from it, because this plant is as tough as leather. It hardly decays, but goes hard in the sun and the sand. This dill has cost the lives of many people who were shipwrecked because they could not swim ashore as a result. The swimmers get entangled in it. Our fishermen also told me that children in Scotland eat this dill, but that is not very believable, even though all countries have their own customs and eccentric tastes.*[6]

In *The Sea and Its Wonders* (1871), Mary and Elizabeth Kirby describe a terrifying sea monster that could easily have made it into Coenen's albums. In ancient travel accounts, sailors often claim to have spotted sea snakes. No one ever got close enough to catch one of these snakes,

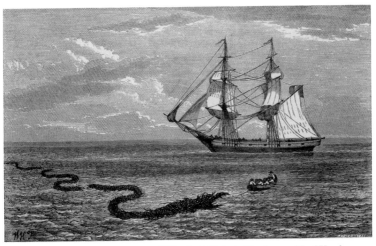

The sea monster described by Mary and Elizabeth Kirby in The Sea and Its Wonders.

until one day a ship, whose name has been forgotten, was crossing the ocean. The weather was calm and the captain looked out over the sea. He suddenly noticed a large sea snake. Its body moved up and down through the waves and appeared dozens of metres long. Its giant head was clearly visible, as was the lion's mane that hung around its neck. Within a few minutes the entire crew was on deck observing the monster. The captain was determined not to let it slip like captains before him. He sent some of his men out in a rowing boat to capture the snake with a length of rope and some rifles.

The sailors rowed until they came close to the animal. It was a massive beast that kept diving down and ducking under, but they managed to tie the rope around its neck and, uniting their forces, they dragged the sea snake back to the ship. Once hoisted on deck, the animal turned out to be so covered in shells and other sea creatures that it was not easy to see what kind of animal it was. After the captain

had stabbed his knife in it, it transpired that it was no more than a monstrous piece of seaweed, 30 metres long and 1.2 metres across.

Why does seaweed so appeal to the imagination? Perhaps because it only reveals itself twice a day at low tide. In the meantime it remains mysterious and open to interpretation. What do we think of? Its flexibility, the way it dances, always moving, free of inhibitions? Its elusiveness? Its slippery body? Perhaps we recognize in it a lifeform and source of food that was crucial at an early stage of human development. During excavations in southern Chile, archaeologists discovered remains of various types of seaweed in the fireplaces and graves of a prehistoric settlement on Mount Verde. This discovery led to the theory that the great migration to the American continent did not take place over land but along the coasts, with (dried) seaweed taken along as provisions.

Between 1750 and 1840, a collective enthusiasm for the coast came about in Europe, especially among women. Shells and seaweed were collector's items you could use to recount your journey to the sea. Until then, the nature that was appreciated was mainly heavily cultivated, while seaweed represented untamed, uncultivated nature. It was hidden under water and survived in an environment influenced by the moon. It was untouched and undiscovered. Just as ferns became precious collectors' items in the nineteenth century, so had seaweed taken on a function as an esoteric, subtle counterpart to the eccentric, fragrant, colourful flowers and fruits popular in the century before that.

When dried, seaweed keeps its suppleness more than flowers do. Each dry specimen retains its former elegance, as though the flexibility never disappears from the cells. You can take a strand of seaweed from a herbarium and place it in water. It doesn't matter how old it is,

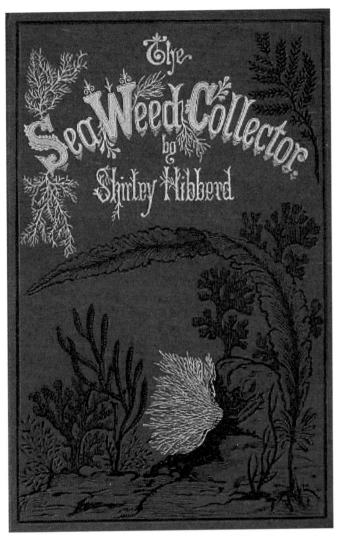

Shirley Hibberd's book, The Sea Weed Collector *advised Victorian naturalists on 'what to look for and where to go' to study British algae. She recommends going out equipped with 'stout boots, a knife, a lens, a memorandum book and a pencil'.*

it will still regain its former elasticity. A dried leaf from a land plant, on the other hand, cannot tolerate moisture: it starts to mould and soon disintegrates.

It is little wonder those well-to-do ladies cast off their bodices at the beach. At the seaside they were able to give free rein to their thoughts and perhaps their limbs became more supple, as gelatinous as seaweed, due to the stretching exercises its picking required. The fashion in seaside attire underwent a change because a long skirt puts its wearer at risk of stumbling and it is hard to jump from rock to rock wearing smooth-soled pointy shoes. Sitting politely on the beach soon went out of fashion; pulling on their waders, people ventured deeper and deeper into the sea. Those who did not dare simply hired a fisherman. Perhaps this admiration and sensory experience of nature at its wildest was a reaction to the 'picturesque' experience of having viewed landscapes from the sidelines and never really being a part of it. Seaweed collectors also found themselves in a liminal position but didn't just gaze quietly into the distance. They moved through the landscape enjoying themselves before taking home the elegant evidence of their toils.

In 1856, John Leech published a cartoon in the British satirical magazine *Punch*. It depicted Victorian seaweed collectors caught up in the euphoria of gathering it. There they were, all bent over in the same direction, heads obscured. Their underskirts are revealed and you can see their legs. The shape of their bent-over bodies reminds me of the cowhide *Luft und Wasserharnisch* [air and water harness], a design by Franz Keßler from the beginning of the seventeenth century in which one can walk along the seabed beneath a kind of inverted cup. (This is the eccentric drawing reproduced on the first page of this book).

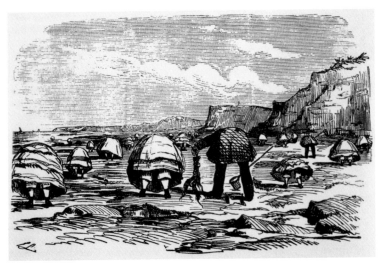

A frequent sight in coastal regions: with their typically bent-over shapes, these seaweed collectors resemble the seashells, barnacles, crabs and seaweed streams they are eagerly searching for. The seaweed-picking mania sketched by John Leech.

Basel University's library contains a stunning seaweed herbarium from 1851. It is a modest book. A red fabric cover with a gold-printed title – *Algae* – encases the 22 blue, green and pink pages. The seaweeds are mounted on small white sheets of paper, slotted into four diagonal cuts like an old-fashioned photo album. Tissue paper covers the delicate specimens.

The album was compiled by Eliza M. French (1809–1889), an American algologist who sold her seaweed samples to collectors. She must have filled hundreds of these albums. Budding tourism and seaweed mania meant great demand. In elegant minuscule handwriting I read the name, place and month in which each individual piece of seaweed was found. The samples look like they were simply plucked from the water and arranged across the page.

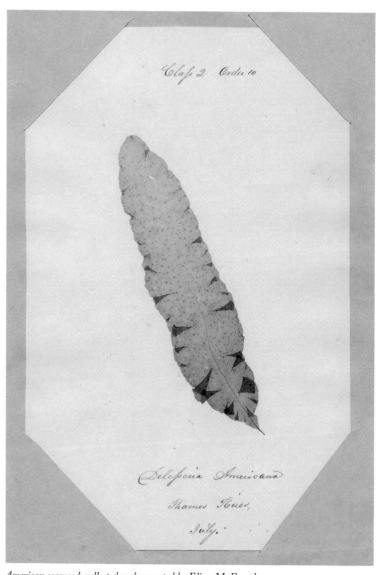

American seaweeds collected and mounted by Eliza M. French.

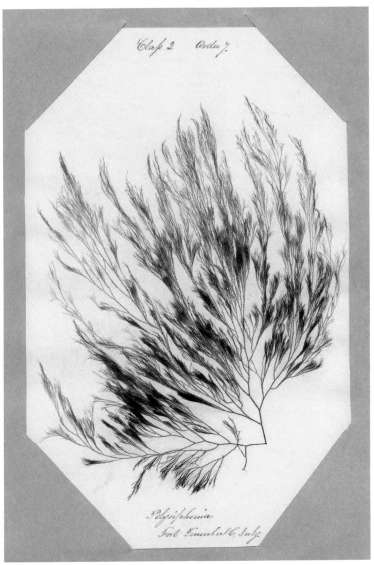

Semi-transparent rice papers cover the specimens like airy summer sheets.

French set to work with endless patience. On the title page, for example, she arranged two garlands of red and green algae by size. A precision that makes me feel uncomfortable. How did she manage to affix this filigree? French loved her material and bent it to her will. Sometimes small irregularities occur, asymmetry, through which the plants display their playful character. For example, the burgundy-coloured *Polysiphoides fucoides* that points to the top left of the page, picked in July, collected at Fort Trumbull at the mouth of the Thames River on Long Island Sound in Connecticut, has been taken out of the water slightly too energetically.

Page 9 from January shows a wine-red *Dasya elegans*, from the East River, New York, with dark winding branches, full in the middle and thinner towards the ends, where a piece of green algae has got entangled. The fifteen-centimetre-long speckled *Delesseria americana*, taken from the Thames River in July, is covered in dark red polka dots. The fragile stipe and the double-folded leaf edges do not seem to consist of plant material but to have been made by a glass blower.

With the utmost caution, I study page 16 with its *Spyridia filamentosa* from Pounder Island, picked in August. The offshoots have become transparent; they seem to emerge from the paper. Page 19 shows a lime-green mossy feathered weed, the leaves of which have been mounted like iron filings. The album is arranged in an idiosyncratic manner. There is no system underlying it, which brings me much closer to the collector than with a field guide, in which the algae are arranged by type. The scalpel with which Eliza French fashioned her seaweeds could be seen as a painting tool.

The album in Basel concludes with a hymn in which seaweed is given a voice:

1

Flowers are we
Of the wild sea
And rocky shore;
Borne by the waves
From hidden caves
When storm clouds lower.

2

Nor sun, nor air,
Nor toil, nor care
Our beauty gave;
Far down below,
Where young pearls grow
Our garlands wave.

3

North winds shake
The chill snow flake
Over the wave
Our fragile forms
Abide the storms
And tempests brave.

4

Flower of earth
Fade at birth
In the summer, say
And the poet breathes
Over pencilled wreathes
His lettered lay.

5

But who shall trace
The passing grace
And melting hue

Of oceans child,
Who treads the wild
Of waters blue!

6

The artist knew
Where Porphyra grew
Of Tyrian clime,
And Ceramia's blush
Hath a brighter flush
For enduring time.

7

Ye may bear us far
As the beaming star
From our mossy home
Yet, a smile we give,
And our crushed hearts live
Where'er we roam.

8

Who love to rove
The verdant grove
For nature's sake,
Come and lave
On the sparkling wave.

9

And a lesson take.
From the coarse and stern
The heart may turn
For beauty's power;
But, under the dross
Of the stern and coarse
Lie pearl and flower.

Once when I was diving, I came across a knot of iridescent rainbow weed (*Drachiella spectabilis*). I wasn't aware that a voice could crack under water. Anyone walking along the tideline that afternoon would have heard my exclamation of wonder through the pipe of my snorkel. I was startled by the sound I made. The weed glowed. From a certain angle, the fronds looked like it had been sprayed an intense Prussian blue. I cut off a piece, but above water it turned out to be a boring greenish-brown in colour, all enchantment lost.

The seaweeds that Anna Atkins (1799–1871) photographed are bathed in that same deep blue. I saw them for the first time in the library of Kew Gardens. The world's very first photo album focuses on algae. *Photographs of British Algae: Cyanotype Impressions* is the title of the book that is four centimetre thick and consists solely of loose sheets. It was brought in on a trolley. I was handed a green velvet cushion to lay the book on and a long thin bag of sand to hold down the pages. Atkins' book was created under water, each page of it submerged. The sun lit up the paper and the seaweed spread on it blocked the light so that its silhouette emerged during fixation in the rinsing bath. Against their blue background, the algae seem to have been laid back in the sea.

As a girl, Atkins enjoyed an education in the natural sciences that was unusual for her time. Her father, chemist and mineralogist John George Children, taught her at home and ensured that Atkins could progress in the field of biology. At the age of twenty-four, she made the illustrations for his translation of Lamarck's *Genera of Shells*. The 250 highly detailed shells demonstrate Atkins' talent, her patience and dedication. Encouraged by William Fox Talbot, inventor of negative

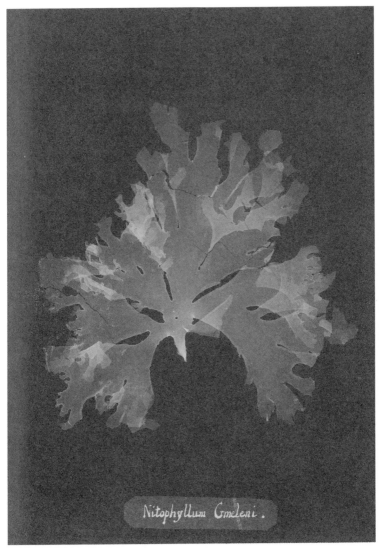

An almost transparent red exotic species, photographed using cyanotype technique by Anna Atkins, floats between science and art.

processing in photography and a friend of her father's, Anna Atkins became proficient in preparing 'cyanotypes', the blueprints invented by Sir John Herschel. She prepared her own paper by applying a mixture of ferrous ammonium citrate and potassium hexacyanoferrate with a sponge. The paper was hung to dry in a darkened room and was ready for use after a few hours. Exactly what the following steps were remains guesswork. There are no pictures of Atkins in action, only a portrait of her in her old age in which she is looking away from the camera, one pale hand restless on a chair, the other hidden in the folds of her striped skirt.

Larry J. Schaaf, who published a facsimile edition of Atkins' prints, *Sun Gardens*, believes that she stripped the seaweed of sand and growths in the sea and, once she got home, immediately continued its preparation with scissors, dissecting forceps and a camel-hair brush. Once cleaned, the weeds were arranged on a piece of paper in a bowl of water, lifted up out of the water still on the paper and then sandwiched in a press between sheets of blotting paper. After a few days, the specimens were dry and ready for exposure. Atkins probably worked well ahead, waiting for the sun so that she could take several impressions on clear days. Her preparations were not only home-made; she was sent dried algae from all over the world through her father's network.

The photosensitive paper is exposed for between five and fifteen minutes depending on the weather. In 1843 she wrote in the introduction to *Photographs of British Algae*, 'The difficulty of making accurate drawings of objects so minute as many of the Algae and Confervae has induced me to avail myself of Sir John Herschel's beautiful process of cyanotype to obtain impressions of the plants themselves, which I have much pleasure in offering to my botanical friends.' Atkins became the first person in history to use the cyanotype technique in

photography. She released her recordings in limited editions and can boast of being the author of the very first published book of photographs. This was the first time a book with illustrations was copied single-handedly and without a printing press. Thirteen copies are known to exist, containing hundreds of unique recordings, created over a ten-year period. The printed species are sometimes large, laid out from the top left to the bottom right, or small and arranged in the middle, making the seaweed seem to float in a sea of infinite depth. However, as scientific records, they fall short. Precisely because of their lack of date and location, the simplicity and intimacy of Atkins' compositions, their transparency, the lack of detailed representation on those radiant blue pages, the algae are given the space to spread out and enchant.

More than 170 years later, the blueprints have lost none of their beauty. It is as though, after seeing them in Kew, they have spread beyond the bounds of the book. Their holdfasts have fixed themselves somewhere inside of me. At odd times they rise up in my mind's eye, floating on the undercurrents of my memory. Should these images ever escape my mind, one of Atkins' editions, with a total of 307 seaweed species, has recently been added to the Rijksmuseum's collection in Amsterdam.

After seaweed's starring role in early photography it also appeared in 35mm film recordings at the beginning of the twentieth century. In his experimental film *H2O*, American filmmaker Ralph Steiner (1899–1986) focused on water surfaces. His film, released in 1929, the first part of a triptych, is a true immersion and silent ode to water's ripples, waves, rays, circles and dimples, orchestrated by wind and

light. Shortly after that, in 1931, his twelve-minute *Surf and Seaweed* was released. Much later, in 1960, he added a soundtrack and called it *Seaweed, A Seduction*.

Steiner focused his camera on the irregular force of the waves; the way the sea rushes ashore and winds back after every roller. After six minutes, the focus shifts from surf to bladderwrack. The water in between the weed looks like luminous white tubes, as if hundreds of glow-worms were hiding there. Seaweed becomes, thanks to Steiner's lens, a leaden substance, neither liquid nor solid. Slowly rippling, it breaks through the sea's surface, almost reticent, but at the same time lascivious in its twists and turns. The soft rubbing and pulsing of the bladderwrack makes for an almost sensuous image, a sensual play between algae and water. The film ends with the sea washing back across the magical bank of seaweed and the wind spinning long white threads from the water.

It was 'that joy of seeing' that inspired Steiner to shoot his first film, indicating that the beauty of objects and the moment of seeing (in other words, the visual experience) was primary to his work, continuing the naturalist tradition in a new medium.

Rougher in nature and more complex in its construction, but also picking up on the beauty of seaweed is *Man of Aran*, an Irish documentary directed by Robert J. Flaherty, which premiered in grand style in London on 25 April 1934. One of the windows of the Gaumont-British cinema even housed a giant stuffed shark for the occasion. The documentary garnered much criticism because it did not offer a realistic up-to-date image of Aran. The family members who played the leading characters turned out not to be related to

each other and the shark fishermen had already forgotten the tricks of their trade. When commotion arose after the screening and the film's veracity was brought into question, Flaherty said, 'One often has distort a thing to catch its true spirit.'

That same year, the film won the Coppa Mussolini (Golden Lion), the prize for best foreign entry at the Venice Film Festival. One winter's afternoon, I put on *Man of Aran*, in a similar black-and-white coloured landscape, and I follow the young family, dressed in wool, fighting the elements. Halfway through the film, seaweed is harvested, not on a calm day, but in the middle of a storm. It blows in all directions. With superhuman effort, a field is laid on one of the bare cliffs. People scratch earth out of the grooves between the rocks, where the seaweed and stones crushed with a heavy hammer, are raked into long thin beds. It is a scene that exaggerates reality, but the

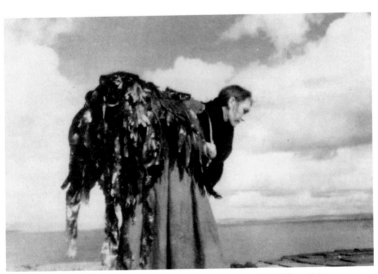

'The Seaweed Gatherer' – a still from Robert J. Flaherty's 1943 film, Man of Aran.

devotion with which new land is won, the striving to make something grow there, moves me. I would like to believe in an indestructible human being who can survive in an extreme environment featuring seaweed.

In early film history, seaweed plays starring role after starring role. Hands filled with kelp swish past in Jean Epstein's 1929 film *Finis Terrae* in which four fishermen camp out on the French island of Bannec to harvest seaweed for three months. They pile up the seaweed and hope that by burning it in the correct manner, they will produce valuable ash. A fight arises in which one of the boys, Ambroise, injures his thumb. He tries to leave the island but fails because of the wind and the pain of his wound. On the neighbouring island of Ushant, people wonder why, on Bannec, only one mound of weed is burning. The alarm is raised and the doctor sails over. Because of the thick fog, he does not notice that he is passing a boat. Jean-Marie, the instigator of the fight, is able to hand over the collapsing Ambroise to him just in time. In the final scene, Jean-Marie sits at Ambroise's bedside and holds him tight.

Epstein shot five films about the sea in his lifetime. He claimed to 'fear and worship the sea. She encourages me to do what I am most afraid of.' Aside from one, all of his films are set on the Brittany coast. Like the rhythm of the tides, which he focused on in his work, he was drawn back and forth to that region.

Finis Terrae was produced without professional actors. Much of the camera work is hand-held and Epstein often added slow-motion montages. He believed that film could show us the fundamental objective truth that is usually overshadowed by subjectivity. In various interviews he said that he swore by what was also the French word for camera lens: *objectif.* The untouched coast enabled him to grasp the

elements in their wild simplicity: the strong, linked arms of the boys, a fluttering hair ribbon, the physicality of life, the undisturbed rocks and many moods of the sea. Jean Epstein offered the viewer – or still does, at least his films have this effect on me – an escape from the alienation of the modern world. In addition, the filmmaker had his own reason to look for alternatives. Under the pseudonym of 'Alfred Kléber' he wrote an essay, 'Ganymède', about homosexual ethics, which was only attributed to him after his death. In the previous Catholic-Church-dominated century, fishermen were more or less sheltered from the strict regime due to their irregular sailing times. In the parallel world of male-controlled fishing, intimate friendships flourished. *Finis Terrae* can thus also be considered a parable: two young men who slowly give in to each other's love, with thanks to the kelp.

Knockvologan, June 17 2017

Yesterday's ebb was at 4.06pm. I waited for the first wave to launch the turn of the tide and searched for red seaweed in the surf. Red seaweed is rarely beached intact, its fronds are often battered or faded in colour so that you can see the sand through them, or other algae that happen to be drifting by in the current. Sometimes the remaining pigment appears to have imploded, turning the seaweed deep red, magenta or fluorescent orange. Appropriately the word 'fluorescent' is derived from the Latin *fluere*, which means 'flowing'.

In the shallow water, the seaweeds appear to be taking part in an artistic diving competition. In slow motion, each individual copy shows itself in different positions: wide-ranging, folded or twisted. Here, lower plants carry out swallow dives, double somersaults and twists to Olympic perfection.

The same movements take place later in the day in a stainless steel sink where, after lots of practice, I place algae on loose sheets of paper. I arrange the pieces one by one above the submerged white paper using a long needle. First the algae must be untangled with the needle. It reacts immediately to touch, swishes the other way and takes on a new shape. I'm sketching under water. A piece of Irish moss that had been floating a second ago touches the edge of the paper. Its tip flips over, no worries, back under water. Again and again, the needle picks up the final fork. Once the last frond has descended, I very carefully pull the paper up at an angle. I lift the wet sheet by its corners and lay the preparation to dry on a towel before covering it with tulle and tissue paper, and pressing down, otherwise it will stick. Plenty can still go wrong, I know by now that seaweed is unruly.

The red seaweed called laver is one of the most difficult types to dry. It shrinks terribly, tugs at the paper and rolls it up exasperatingly, seaweed and all. Anyone wanting to start a collection would be better off trying brown algae. Rinsed in salt water you can simply hang it over the shower rail or lay it on a rug in your living room to dry. It stands out beautifully against a whitewashed wall.

In one of the Victoria and Albert Museum's white high-ceilinged rooms, Julia Lohmann is examining a green semi-translucent structure. 'Naga kelp is extremely elastic and sticky,' Lohmann says as though the green shape she is holding has formed itself. The hollow strips of aluminium, reed and seaweed are reminiscent of the architectural plant studies made by photographer Karl Blossfeldt, but also of Ernst Haeckel's detailed drawings. Under Lohmann's leadership, all these individual components have been brought together in an impressive

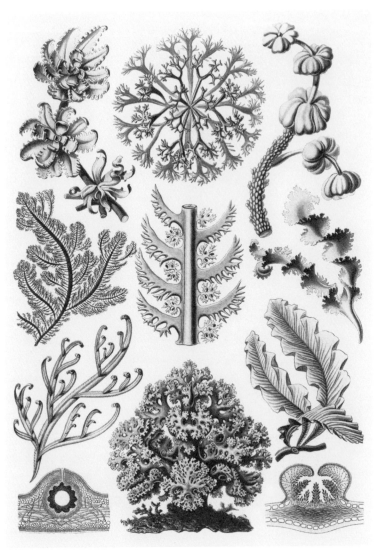

Ernst Haeckel carried out field research on Helgoland as a medical student, alongside his professor, Johannes Müller, fuelling a life-long love of seaweed and jellyfish.

sculpture called *Oki Naganode*, which has since travelled to all the major European museums.

Lohmann is a designer and one of the pioneers of the international seaweed industry; her focus is on innovation. In 2007, she visited a kelp farm in Hokkaido in northern Japan, where most of the *nori* sheets come from. She was surprised that kelp was not used as a building material. In a country where seaweed is part of the food culture, other uses of kelp had not occurred to anyone.

In 2013, during a residency at the Victoria and Albert Museum in London, she founded the Department of Seaweed, initially a platform for exchanging knowledge about seaweed and exploring it as a material. By now, the Department of Seaweed has grown into a collective research project for which she will soon be awarded a PhD. Her dissertation focuses on the social role of designers and the applications of seaweed in contemporary design. In addition to reporting on attractive experiments, she argues for sharing acquired knowledge. 'Seaweed as a material cannot be compared with any other raw material,' says Lohmann. 'So we shouldn't look at other industries, but develop new, clean processes.' A small circle of specialists brought together by Lohmann works at the Department of Seaweed: students from the Design Academy in Eindhoven and HFBK in Hamburg, a French textile designer, a New Zealand carpenter and a British anthropologist. 'The first ring,' she calls them. 'It's funny,' says Lohmann, 'I'm getting more and more convinced that seaweed selects people rather than the other way round.'

Over time, Lohmann hopes to expand the department to work with more seaweed colleagues worldwide. Seaweed is a material that is ideally suited for making connections and forming colonies.

A sketch of Oki Naganode from Julia Lohmann's dissertation. The complex seaweed construction stands solidly on the ground but looks more springy than a trampoline.

Her working method is reminiscent of the way in which seaweed multiplies.

It seems that seaweed has been used throughout history in many coastal cultures to make objects, but since the material is perishable they have not been preserved. The objects might also have been so mundane that their use wasn't transmitted orally or in writing. Moreover, a large proportion of the people who used these objects were unable to write.

'Washed away by the tide,' Lohmann says, aptly. And not only have the objects become lost but also the craftsmanship has disappeared. Lohmann is trying to pump life back into these techniques. Kelp inspires her as a raw material for applications, for example as a veneer, and she tries to process it so that it remains flexible and transparent and she can model it.

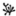

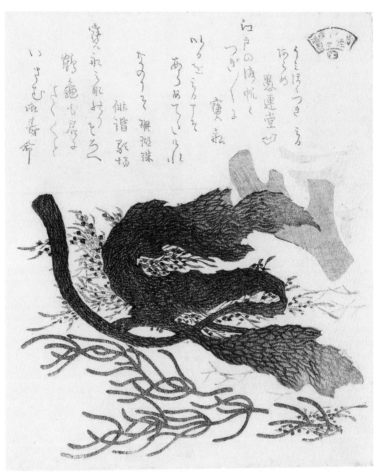

The woodcut produced between 1810 and 1850 by Kubo Shunman shows three different algae and haikus by Haikai Utaba, Takarabune and Gurendô Nakakubo.

In addition to the precise scientific drawings that were produced in the West, there are oriental drawings in which algae have a different symbolism. The art of capturing the essence of things, not reproducing something to perfection but sketching it in all its simplicity, was regarded as the highest pursuit of an artist during the Western (206–208 BC) and the Eastern Han dynasties (25 BC to AD 220). In China in these periods, Zen poems were written in a loose *caoshu* or cursive script, with simple, sketchy forms of the individual characters. The poets chose the thinnest rice paper, which meant that they had to start all over again after the smallest mistake, because it was impossible to erase anything from the delicate paper. In this way, masters and mistresses tried to give an impression of spontaneity, both in terms of content and technique.

Centuries later, between 1730 and 1880, coloured woodcuts called *surimonos* were produced in Japan. The Rijksmuseum in Amsterdam owns two such *surimonos* on which seaweed is depicted in combination with cursive script: a still life, and a lobster's feeler with a bit of seaweed on it. A *surimono* is a luxuriously executed print with images combined with one or more poems. Thick paper, blind printing and metal pigments, such as copper and silver powder, are often used in the printing. The prints were usually commissioned by poets and served as an exclusive gift to friends and business relations.

Seaweed almost always suggests prosperity in Japanese poetry. In classical poetry there is often talk of *tamamo*, which is usually translated as 'valuable seaweed' or 'gemweed', but it is unclear whether this meant a specific seaweed or not.

The haikus on the *surimono* with the lobster feeler all refer to the New Year. Perhaps the depicted crustacean was served as one of the

finest parts of a *osechi-ryōri* party dish. One of the haikus on this print reads:

> *Let us beg the old*
> *bamboo-cutter for this:*
> *bamboo decorations.*

For New Year in Japan, the gates of important buildings and the doorposts of houses are hung with garlands made of bamboo, a symbol of prosperity and longevity. Seaweed decorations are also often added.

New Year and seaweed are connected in an even closer way. In the city of Kitakyūshū, which overlooks the Hayatomo mountain in the province of Fukuoka, the following ritual has been performed for centuries. On the first day of the new year, at sunrise, three priests walk into the icy water to cut seaweed, at the mercy of the currents and the tide and with only a torch to light their way. The freshly picked *wakame*, the first of the year, is offered to the gods on the Mekari altar. It is believed that the fresh seaweed will bring good luck for the new year. In the past, the Mekari ceremony was performed in secret; nowadays, you can witness it from a distance.

The Japanese word *ukiyo* has its origins in Buddhism and once expressed the transient, fleeting nature of reality. Literally it means 'floating world'. In the mid-eighteenth century, woodcuts made in the *ukiyo* style became popular in Europe. They had a major influence on the European fin de siècle art world. Gradually, the term came to refer to a restless searching for the transitory joys of life. These days, the meaning of *ukiyo* has transformed further to 'dangerous life' and 'dare to live'.

The Seaweed Harvest Ritual in Nagato *by Totoya Hokkei.*

This *ukiyo-e* bears the title *The Seaweed Harvest Ritual in Nagato* and is part of the 'Famous Places in the Provinces' series by Totoya Hokkei (1780–1850), made around 1834. You can immediately see that harvesting is a dangerous task. A high wave rolls over the two seaweed pickers; they run for their lives as they gallop together through the curl of the wave reminiscent of Hokusai's *The Great Wave of Kanagawa.* Hokusai was Hokkei's teacher. Is the figure on the left wearing a jacket, or has he placed a large *kombu* around his shoulders? Beneath the wave, we see the green of his mantle reflected, or is that seaweed too?

Japanese poets from the Edo period experienced a devilish pleasure in shortening and distorting their *kana* (syllabic scriptures) in all possible and impossible ways, in accordance with their own handwriting. Apparently there were few rules. Hokusai too distorted the usual characters, producing them sometimes one way and at other times another.

The *surimono* illustrated on page 50 was composed as a still life with algae. Its verses includes New Year wishes and reflections on the richness of the sea and are again full of wordplay and double meanings. *Miru* in the first verse is a kind of seaweed but also means 'seeing'. *Arame* is the name of another species and also means 'if only we had', and *nanoriso* is also a kind of seaweed, but the declension used here means 'saying your name'.

If only we had
seashells and seaweed!
– Gūrendō

Ship's sails from Edo,
one by one –
boats full of treasure.

Oh how stunning
to see them sail there!

Like red coral when the poets announce their names
for the poetry session

All neatly in a row in the treasure ship
cranes and tortoises too,
to inspire you, sir, to longevity.[7]

The verses were probably addressed to the emperor or some other nobleman.

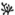

After an afternoon's beachcombing I see the silhouettes of the algae spread on the sand projected on the inside of my eyelids at night

before I fall asleep: green and red, brighter than in reality. The seaweed floats freely inside my head, like the colourful stickers I stuck to the car's windows as a child.

In Amsterdam, I visit 'Matisse's Oasis', a retrospective in which the artist's work is linked to that of contemporaries such as Malevich, Mondrian, Cézanne, Seurat, Kirchner, Picasso, Rothko, Van Gogh and Manet. Each of these masters steered their own course and developed works in which the real world was made abstract. Henri Matisse was inspired by the many forms seaweed takes during a trip to Tahiti and, once he was back in his studio, he began to paint shapes that reminded him of the exuberant flora and fauna of the island. Birds, corals, fish, jellyfish, sponges were simplified into colourful symbols that came together in dreamy images freed from the restraints of gravity.

In 1941, Matisse was bedridden for months following a stomach operation. Painting became impossible. Assisted by Monique Bourgeois, a young nurse, Matisse developed a new working method by cutting shapes out of paper instead of using a brush on canvas. Bourgeois coloured the papers for him. She held up the clippings against the wall opposite Matisse and pinned them up according to his instructions. That is how his first series of collages was created, out of necessity. If you look at them from close up, there are little jags everywhere in the clippings. The lines do not merge seamlessly with each other. Curves behave in a contrary fashion, but the shapes still come together, falteringly, not exactly streamlined. The silhouettes have clearly grown from scissors and paper. Matisse continued to cherish the dynamics of cutting and the growth of his silhouettes. It is precisely this irregularity in the forms that makes his compositions so lively.

In 1943, long after Matisse had been declared cured, Monique
Bourgeois decided to join the Dominican sisters of Vence convent,
close to where she had nursed and assisted Matisse. A couple of years
later, in 1947, Sister Jacques-Marie, as she was now called, showed
Matisse her sketch for a stained glass window. She told him that
the sisters wanted to have a new monastery chapel built, the Rosary
Chapel. Matisse had never been a member of a church and had no
experience of religious art, but the thought of designing a window
appealed to him so much that he suggested making the design for
it. It turned out to be more than just a design for a single window:
for four years he worked on what he himself later would regard as
his masterpiece. Matisse painted a Madonna and Child on the white
wall tiles of the chapel with sparing black brushstrokes, and designed
the pews and the floor. The chasubles were the last to be designed.
These robes are made of fabrics that Matisse picked out himself and
were sewn under his supervision at the Dominican sisters' Atelier
d'Arts Appliqués in Cannes.

In 1952, the designs for the chasubles, which traditionally each
have a different colour (aside from red, they are also green, white,
purple, black and gold, relating to the ecclesiastic liturgy), were still
hanging on the wall at Matisse's home. They were admired by visitors
such as Picasso and compared with pinned butterflies. Alfred Barr,
author of the first standard work on Matisse, counted them among
his purest works.[8]

The chasubles are still worn for Pentecost and on the martyrs' name
days. Then the Vence Chapel is transformed by a play of colours as
daylight is projected onto the stone floor through the stained glass
drawings. Seaweed made of light. The simple black lines, painted
by Matisse on the wall, are illuminated by radiant yellow and green

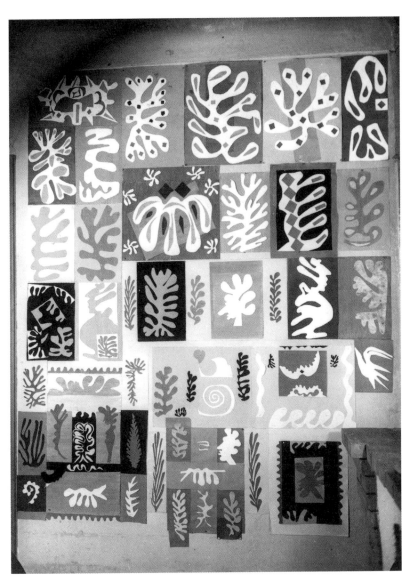

Matisse's studio in Villa le Rêve, Vence, May 1948.

sunlight streaming in through the windows. The priest's slow gait and arm movements allow Matisse's forms on the chasuble to move freely through the space, bright and autonomous within a complete oneness.

The sea begins somewhere else each day. I head for the surf in a straight line. The waves of the retreating tide have whipped up the sand. My feet sink into it. I wade through knee-deep water and feel the cold sea seep in through the holes in the knees and elbows of my wetsuit. Beyond the island of bladderwrack, I make my first crawl strokes.

In the sea, one writes without chair legs, footstool and desk. There is no slow work, no more staring out of the window or eating apples. As an underwater writer you have to discard everything, be submissive, strap on lead blocks; otherwise, you will float back up to the surface and all the newly written words will ebb away.

The forest that I swim through is powerful. The algae seem to be driven by a mysterious current, they calmly wave back and forth. While snorkelling in the bay I lose all sense of scale. I have never seen a landscape so slowly and completely in motion. Loose fronds float past below and above me. Many are almost transparent, but none of them look lifeless. Jagged leaf edges, torn-off stems, broken-away holdfast, only out of the water does the seaweed surrender to the test of time and shrink away. Decay is nowhere to be seen under water.

To my left and right I can see in the corner of my eye how algae each have their own substrate and territory. I try to concentrate on the different stages of development and investigate various clusters for their shape and size. I look around as I hold on, slowly flippering,

one hand clutching onto a rock. The sea here is so clear that the sun projects the rippling surface onto the bottom. Everything is moving: the water, the rays of light, the seabed, the seaweed and the creatures. Two young dabs shoot away, the red tentacles of the mottled anemones waft back and forth, and a small school of needlefish hide when my other hand creates a shadow. On the algae I see other algae. I run my fingers over a kelp leaf with a delicate brocade of *Obelia geniculata* attached to it. I do not pick it, even though I can barely resist doing so. Millions of zoospores and gametes around me are already on their way to creating a new generation. All these travelling particles that carry life within them and will settle on the seabed or some other surface have a strange effect on me. Will they settle on me too? Is the water making me permeable? In all this interconnectedness, you might see an example of an ideal world in which species are tolerant and offer each other holdfast in the current in order to survive. Pure symbiosis.

KNOCKVOLOGAN, 15 AUGUST 2019

'Form forms forms,' says designer Maria Blaisse as she lifts a dripping *Saccorhiza polyschides* from the surf at Bàgh a' Chnoic Mhaoileanaich. 'Look, everything is so precisely in tune,' she continues, showing me the weed's undulating character by cutting open the stipe with a penknife. Her voice is rapturous. 'If you run your finger along the ruffles from this kelp's base, they will lead you back to the inner spiral, which has caused the edges to curl.'

For two weeks we collect and study freshly washed-up brown algae and wade past the banks of weed on the rocks to explore seaweed's

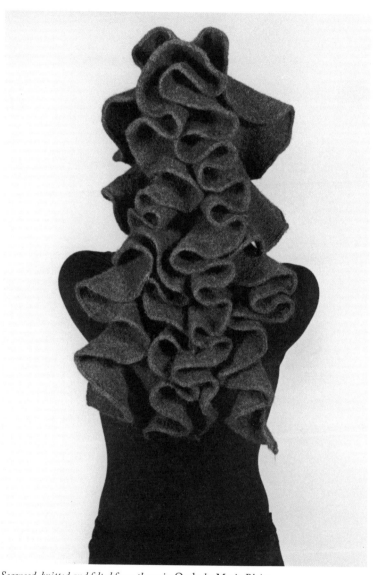

Seaweed, knitted and felted from the series Onda *by Maria Blaisse.*

ability to stand up to whatever the directional pull of the current. The curling stems channel water upwards, allowing the plants to rise up in immense intertidal forces and replenish themselves with daylight.

Blaisse seeks the potential qualities of the materials she uses and is fascinated by their inherent movement. Since the 1980s, she has been exploring and developing numerous curved shapes, such as wearable sculptures that wrap themselves naturally around the wearer's head or body. The forms are highly architectural.

Her pieces are all variations based on the emergence of form from the concave and convex parts of a doughnut shape. Blaisse's work is a continuous dialogue with materials, precise observations, analysis, humour and her response to an overdesigned world. Her aim is to incite a flow of continuous creation, to develop work that is alive and alert, and to invite designers to move beyond waste.

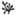

The American painter Ellsworth Kelly had started studying Fine Art at the Brooklyn Academy when he was sent to France as a soldier during the Second World War. He served with the 603rd Engineers Camouflage Battalion, also known as the 'Ghost Army', and was involved in the camouflage of military installations and subterfuge manoeuvres and decoys to mislead the enemy.

Undoubtedly influenced by the precision that camouflage requires in a specific area in two and three dimensions, Kelly's pursuit of concrete forms that do not represent anything but are purely formal is understandable. In the mid-1940s, Kelly started making line drawings of plants and flowers. His plant studies are mainly contour drawings of leaves, stems and flowers, entrusted to the paper in flowing, striking lines. However minimal, Kelly's work is extremely dynamic in nature.

A challenge for seaweed to maintain its symmetry in an empty sea. Ellsworth Kelly's Study for Seaweed, *1949.*

The plant forms are captured in firm lines. Kelly copied the parts using tracing paper. During the war years, his eyes became trained in light and dark, foreground and background, shape contrasts and camouflage colours, a specialism that he began to apply in his own work. Subject and ground come together in this series. It is a flat kind of reality, but brimming with vitality and, no matter how much white there is on the page, his work never resembles a sterile herbarium.

Between 1947 and 1949, Kelly drew a selection of seaweeds. For his *Study for Seaweed*, he stuck a piece of kelp to the door of his Breton cottage in Belle-Île. He wanted his drawing to be as pure as possible. The shadow lines, which may only be pentimenti and actually concern a correction because the kelp did not end up in the middle of the paper, are allowed to remain. The image thus appears like a cut-out,

but because Kelly has framed the entire plant the algae gains an ambiguous quality. It is fixed and free at the same time, reflecting the way that kelp anchors itself to the substrate.

When a hailstorm breaks out over the beach, the hail starts by filling up the ripples in the sand. The waves from earlier are now marked out; a wave of hailstones above a wave made of sand. Wind lashes the hail low across the mudflats towards the surf; seaweed blocks its path, causing a pileup. I watch the bouncing balls. On the windy side, the seaweed turns increasingly white. The hail accumulates until letters seem to appear; an as-yet-unreadable text is written on the beach in compressed ice. Each piece of beached seaweed generates a different font. Kelp stretches letters into capitals, while strands of rockweed make notes in italics. Larger hailstones are attracted to larger algae, smaller hailstones to smaller algae. When I walk back half an hour later, the text has moved along a little and the white shadowy edges around the seaweed have been erased.

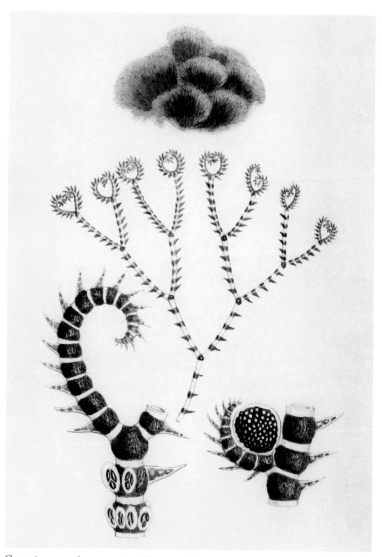

Ceramium acanthonotum *from* Phycologia Britannica, *described and drawn by*
William Henry Harvey c. 1849.

4

Wilful Weed

Sea-weed sways and sways and swirls
as if swaying were its form of stillness;
and if it flushes against fierce rock
it slips over it as shadows do, without hurting itself.

D.H. Lawrence

SEAWEED IS OFTEN TOO BIG TO PUT IN A PRESS, so it is frequently folded in two when preserved for research purposes. Illustrators have no problem with this and simply depict the weed the same way. When I asked the curator at the Dutch national herbarium in Leiden how seaweed should be mounted, he told me, 'You should show holdfast, stipe and fronds. All three components picked in different seasons are valuable to a collection, but a phycologist is not really that bothered about composition.'

I didn't believe him. If you invest so much in the perfect presentation of a species found at a specific date and place, you don't just place it randomly on the paper; you arrange it as naturally as possible. The scientific drawings in Professor William Henry Harvey's *Phycologia Britannica* are painted with the finest brushes and the brightest ink. The algae he collected were transplanted to the two-dimensional plane with incredible elegance. Sometimes two different species

are set close together, so close that it makes me blush. This is not only a scientific representation, it is a declaration of love. The algae is matched by the ink. Harvey depicts it cut through so that you can see the insides, the skin of the stipe, the structure of the cells and a schedule of reproduction. You can see from the image how unmanageable the seaweed must have been. Harvey knows how to handle it. He sits bent over his muses for hours and hours. He places the fold halfway down the kelp precisely in the fold of his book. This attention to detail can only come from someone who cares deeply.

In Linnaeus's system, algae as well as mosses, ferns and lichens are classified under the general name of 'hidden-reproduction plants' or cryptogams, because their reproduction is not visible to the human eye. *Cryptos* means 'hidden' and *gamos* 'marriage'. No matter how covert their flowering, seaweeds are masters of seduction. They belong to the most sensual family in the plant kingdom. It's no coincidence the word *wakame*, which means 'young girl' in Japanese, also alludes to the seaweed pickers who mirror the elegant movements of the algae.

Many Japanese poems referring to seaweed were written during the Heian period between 794 and 1185. At the time, seaweeds were associated with love and desire. A very early example of this is Kakinomoto no Hitomaro's *chōka*, written between 660 and 720, in which he mourns a lost love.

> *In the sea of Iwami*
> *By the cape of Kara*
> *There amid the stones under sea*

Grows the deep-sea miru weed;
There along the rocky strand
Grows the sleek sea-tangle.

Like the swaying sea tangle,
Unresisting would she lie beside me —
My wife whom I love with a love
Deep as the miru-growing ocean.

But few are the nights
We two have lain together.

Away I have come, parting from her
Even as the creeping vines do part.
My heart aches within me;
I turn back to gaze –
But because of the yellow leaves
Of Watari Hill,
Flying and fluttering in the air,
I cannot see plainly
My wife waving her sleeve to me.
Now as the moon, sailing through the cloud rift
Above the mountain of Yakami,
Disappears, leaving me full of regret,
So vanishes my love out of sight;
Now sinks at last the sun,
Coursing down the western sky.

I thought myself a strong man,
But the sleeves of my garment
Are wetted through with tears.

There are also anonymous poems about seaweed as a metaphor for love and longing, like the following two:

Gemweed on the waves
Washing neither out to sea
Nor in to shore:
Floating all a-tangle in the tide
Will my love drift on across the years?
 KOKIN WAKASHŪ XI:532 ANON

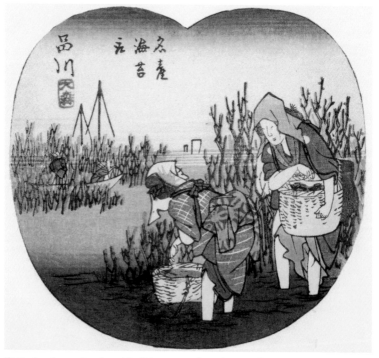

Gathering Seaweed at Omori in Shinagawa – from the series Cutout Pictures of the Tokaido Road (Tokaido harimaze zue), c. 1848/52, Utagawa Hiroshige.

As the gemweed drifts
In the offing of the mighty deep,
So let us drift in sleep:
Come to me quickly, O my love,
For I must suffer if you make me wait
 MAN'YŌSHŪ XII:3079 ANON

The smoke from the kelp fires on the beach to extract salt could not satisfy the burning desires of Fujiwara no Hideyoshi (1184–1240).

From the huts on the shore
Where sea folk burn the briny wrack
Smoke rises in the dusk,
As rumor rises to my hurt
 [From *These still smouldering fires of love*][9]

Fortunately we can console ourselves with the following extract that was written almost five hundred years later. The British nature writer Roger Deakin becomes completely entangled in green algae as he swims towards the sea in the River Erme in Cornwall:

I threw myself in ... I felt the incoming tide lock on to my legs, and thrust me in towards the distant woods along the shore. Each time a frond of sea-lettuce lightly brushed me, or glued itself around my arms, I thought it was a jellyfish, and flinched. But I soon grew used to it; seaweed all around me, sliding down each new wave to drape itself about me. I kept on swimming until I practically dissolved, jostled from behind by the swell.[10]

If they had seen the colour lithograph of sea lettuce in *Flora Batava*, the Lumière brothers might have recorded a follow-up to their famous *Danse Serpentine* from 1896: an all-green version, coloured frame by frame. In their film, the inventor of the serpentine dance, Loïe Fuller, dressed in a very wide, loose costume, waves her arms around like windmill blades. Her skirt and sleeves pan out around

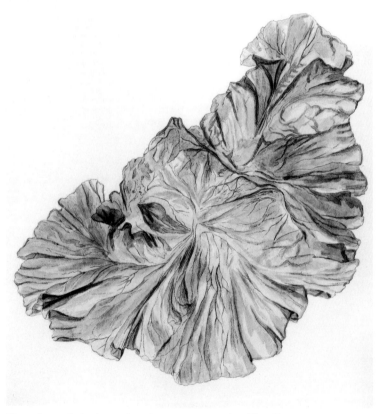

The sea lettuce depicted in a coloured copper engraving from Flora Batava.

her. The many metres of fabric move up and down in such a way that the dancer's head and body disappear. The silhouette resembles a budding and closing mullein flower, while it also revolves horizontally. It is an absolutely enchanting image that flutters and swirls for minutes, unrestrainedly exuberant like a leaf of sea lettuce that has broken free.

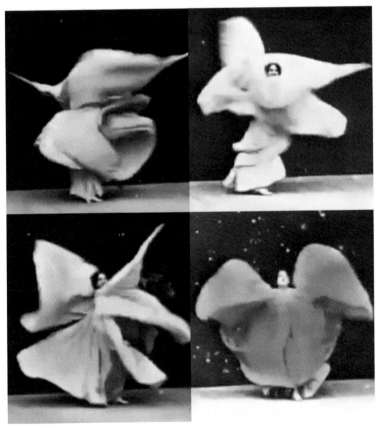

The dizzying pirouettes of Loïe Fuller dressed up as a sea lettuce for her Danse Serpentine.

Women in seaweed outfits, why not? In the *Hammond Lake County Times* from Sunday 10 December 1920, I find an interesting headline:

<div align="center">

HULA-HULA SKIRT?
Ruth Picks One Out Of The Ocean
Ruth Roland and her hula garb

</div>

Ruth Roland, movie star, wanted a hula-hula skirt one day but the big cost of the necessary grass halted her until she had a brilliant idea, seaweed. So she just took a dip and came up with the shirt – so the camera man avers.

I wish I could have seen her dance in her salty outfit. I imagine it was the most eye-catching one of the evening. Wearing such an exotic skirt, she must have been tempted to keep whirling around, because at rest it would have lost much of its charm.

<div align="center"></div>

Alfred Guillou (1844–1926) painted a peaceful image of a young mother with her sleeping child: *Mère et enfant au bord de la mer*. *Mère* and *mer* (sea), how close those words are. The child has been laid to sleep on the bladderwrack. The soft surface is cooling. The mother's gaze is tender and alert. She is knitting a stocking or hat with four knitting needles and tenderly turns her head to the child, who is dreaming deeply in a sky-blue dress. Undoubtedly the weeds left a print on the sleeve and the skirt, a subtle print like damask, a tissue of shadows.

In 1790, the Irishman William Kilburn (1745–1818), trained as a textile printer in Dublin, and one of the three illustrators of William Curtis's six-part *Flora Londinensis*, designed a costly fabric for Queen Charlotte, the wife of King George III. The design was based on

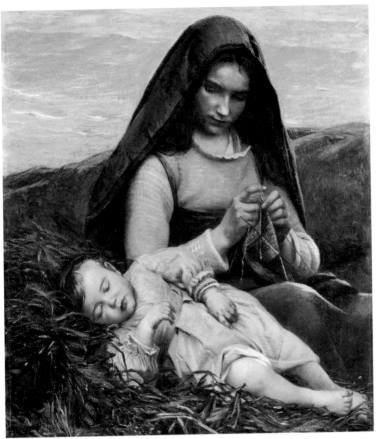

Sleep-inducing bladderwrack: ideal as a day bed when the sun is at its strongest.
Alfred Guillou, Mère et enfant au bord de la mer, *late nineteenth century.*

different types of seaweed, printed on cotton in seven colours. Large wooden printing blocks carved with the seaweed designs were produced by Kilburn's calicot printer's shop in Wallington, just outside of London.

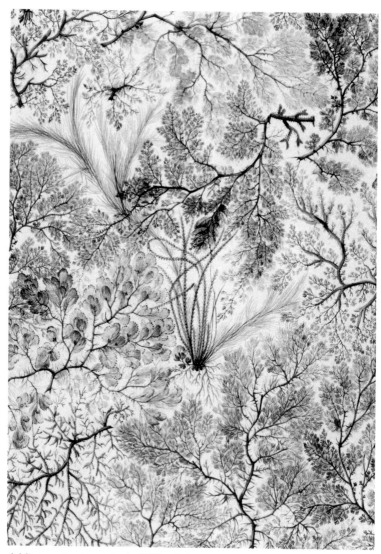

A delicate watercolour design by William Kilburn is almost indistinguishable from an actual seaweed arrangement.

In the Victoria and Albert Museum in London, there is an album of 223 watercolour sketches dating from between 1788 and 1792. Many of them represent native plants that seem to have escaped from the *Flora Londinensis* and gone wild. Among the designs are thirty detailed sketches depicting seaweeds and corals, some true to life, others more stylized. On one sketch, underneath a piece of painted paper the size of a square centimetre, a minimal correction is visible that bears witness to Kilburn's far-reaching pursuit of perfection. No matter how light and elegant these designs may appear, they have been subjected to a strict inspection down to the millimetre.

In the museum's restoration studio, a dress is laid out on one of the long tables, made from a fabric designed and printed by Kilburn, most likely of hand-spun unbleached cotton, on which seaweeds in purplish-black, plum, purple and lilac colours seem to be inseparably intertwined. The pattern consists of so many layers, it is difficult to trace the order of the various printings.

'The dress itself is in poor condition: worn, partially torn and sloppily patched up,' the restorer says. 'We bought the piece because it is the only example of Kilburn's authentic fabric left.' The dress lies there, voluptuously pleated. I recognize the pattern from the *Kilburn Album*, although the printed lines on this fabric are a bit wider. The virtuosity that radiates from both the details in the drawing and the complexity with which the differently tinted algae seem to be repeated randomly, forming a subtle braid together, celebrate the exceptional connection between the precise naturalistic illustration and the craftsmanship of the woodblock cutters. It is not a logical choice to translate such delicate designs into one of the coarsest printing techniques. Only excellent craftworkers can accomplish the task.

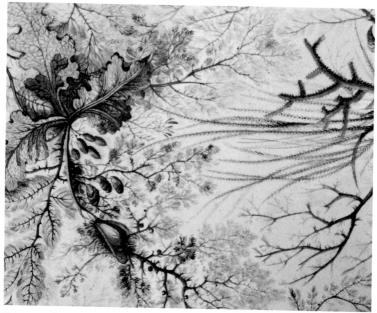

This seaweed miscellany by William Kilburn was printed on cotton around 1782.

Kilburn's designs may also have been drawn according to the fashion of the time. The idea of the seaside as a place to take a casual stroll plus increasing attention to the scientific classification of organisms living in the mysterious and terrifying sea were both flourishing. Josiah Wedgwood, the English potter, was very fond of shells, collecting them from all over the world and often using them in his patterns. He especially liked shell-and-seaweed designs on dessert sets and, to set them off more naturally, he gave the ground glaze a slightly green tint.

Kilburn's choice of seaweed motifs on high-quality cotton fabrics was an intelligent strategic move to increase profit. With his textiles,

he created an opportunity for the bourgeoisie to show these newest discoveries to the outside world. A cabinet of curiosities, a collection of illustrated scientific books, an exotic shell collection, and also a gown printed with seaweed, conveyed that progress and a sense of discovery.

To his great displeasure, Kilburn's fabrics were copied by rival firms, sometimes within ten days. Nobody could compete with his designs. The fabrics were of lesser-quality yarn and not nearly as colourful, but cost two-thirds of the price Kilburn asked for, so they still found a market. He was quite right to want to curb the plagiarism. William Kilburn was the first to lobby for copyright for textiles. In 1787, he signed a petition to protect designers. For the first time in history, designs on linen, cotton, calico and muslin were protected by law for a period of two months, which, although not very long, did somewhat delay their copying.

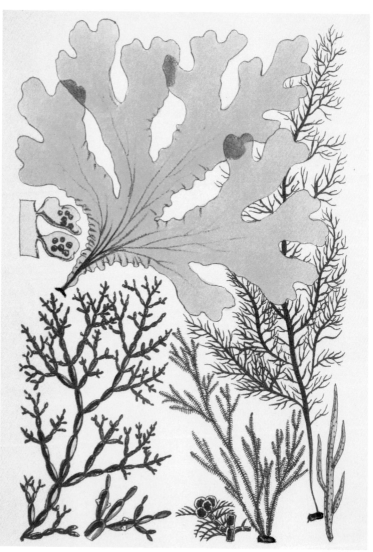

On a drawing by Samuel Octavus Gray, a paper-thin Callophyllis laciniata *covers the asparagus-like thalli of two red seaweeds.*

5

Sound Waves

EVERY WORD THAT EXISTS was once spoken for the first time. Frequently its inventor is also the discoverer of what is being named. I often wondered where the 'wrack' in the English names for seaweeds came from. Dr William Turner (1508-1568) compiled the first scientific treatise on plants, labelling seaweeds 'seawrake'.[11] This was a reference to their origin, having washed up from the sea like shipwrecks do.

Species' characteristics often prevail when capturing something in words. A name as manual and crib sheet. It helps us to get to know new species and to identify them. It is only logical that, as a novice collector, you don't immediately brave the Latin names. Browsing through the algae guidebooks you first pick up the names in your mother tongue and almost automatically inculcate their physiognomy, based purely on appearance. A procession with the most colourful seaweed floats passes by. The English excel in this: Beautiful Eyelash, Pink Plates, Purple Claw, Shaggy Hair Weed, Rosy Dew Drops and Oyster Thief.

When it comes to names, Dutch marine biologists remain sober, apart from the odd splurge like *bloedrode zeezuring* – 'blood-red sea sorrel'. Take *Codium*, which is called *viltwier*, literally 'felt seaweed', named after the dark green cloth that spans a billiard table. In

German, the emphasis is placed on shape and it is called *Gabelzopfalge*, indicating the prongs of a fork. The French gave it the beautiful name *algue chou-fleur* – cauliflower algae. Particularly when you look down on the seaweed from above, it does seem to have the structure of cauliflower rosettes. The English go one step further: they are more resourceful and give this velvety seaweed poetic names such as Green Sea Fingers, Dead Man's Fingers, Atlantic Green Sponge Fingers, Green Fleece, Sputnik Weed and Velvet Horn. Names often betray the habitat or the dispersion of a species, for example, *Cladophora vagabunda*. Linnaeus gave it this name because the seaweed roams freely and multiplies across the world.

In a language that is spoken far from the sea – for example, Rhaeto-Romanic in the Swiss Alps, there is no word for seaweed. If anyone wants to talk about seaweed there, they will probably use the German word *Meeresalgen* or Italian word *alghe*. Rhaeto-Romanic is threatened with extinction. There are only 36,000 speakers left and many words have become lost due to it only being used orally. In an attempt to save the language, in 1904 Robert da Planta began compiling a dictionary, the *Dicziunari Rumantsch Grischun*. The collection of words for this work can be traced all the way back to the sixteenth century. The fourteenth volume has now been released and the letter M is currently in progress. The precious collection of words, which comprises around five million archive cards, is stored on microfilm in a bunker near the Gotthard Tunnel. Chasper Pult Jr, etymologist, radio producer and curator – named after his father Chasper Pult, who together with Florian Melcher helped da Planta to collect words – checked for me whether a word for seaweed had ever been noted. The only link he found was the word *ritscha*, the plural of the word for 'lock of hair'. Browsing back through older dictionaries he found a completely different meaning

in the *Dizionari dels idioms romauntschs* (1895) by Zaccaria Pallioppi: a fairy-tale creature, an old woman who emerges from the water and drags naughty children down into the depths.

To small children who helped with the dishes, people used to say, '*Guarda, uossa vain la Ritscha*' ('Beware, or the mermaid will come') as the water went down the plughole. With the whirlpool that formed in the sink, children were warned of the danger of water, which could pull them down when they were playing by the well or in a stream. Equally, the expression '*Scha tü nu fast da brav, clomi la Ritscha!*' ('Be good, otherwise I will call the mermaid' – who was rumoured to kidnap children and chain them up) seemed to be very common. Fishermen in Graubünden still say '*Bütscha la Ritscha!*' ('Kiss the mermaid'), when wishing each other a good catch. This seems to

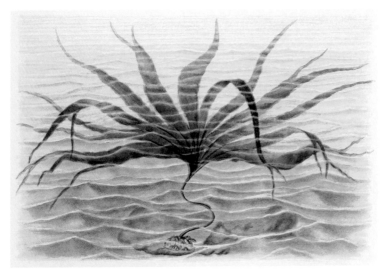

Laminaria digitata *grows unusually fast in clear water, particular in places rarely uncovered by the tide.*

me a rather difficult task for those who only fish in fresh water. The appearance of the letter R volume is planned for 2039. Chasper Pult Jr has promised me there will be a seaweed entry in it.

Dutch-Indonesian poet G.J. Resink lived in what he called 'a liminal world'. Border zones, often coastlines, represent his inner state in his poems, such as this one, entitled 'Seabather':

> *He stands hip-deep in the waves,*
> *half human being half chunk of coral,*
> *where a mollusc in an ashamed shell*
> *is rocked by seaweed and waves.*
>
> *When foam splashes over his trunk*
> *he becomes something from an ancient tale,*
> *though escaped the distant folk forever,*
> *myself excepted, who bears witness to him*
> *in a foreign tongue but breathes in him.*[12]

In May 1403, shortly after the appearance of a shooting star, a violent storm raged across the Zuiderzee, lashing holes in the surrounding dikes. When driving their cows after the storm, Edam milkmaids saw, a strange being swim into Purmer Lake through one of the broken dykes. They fled the monster, which was partly hidden by seaweed. Every morning and evening, the milkmaids rowed back and forth and they became so used to the 'untamed female character' that, after a week, they were able to fish her out of the water. They took her by milk barge through the Purmerpoort to Edam, where they scrubbed and dressed her green body and fed her.

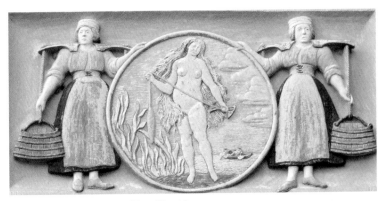

The Mermaid of Edam, tamed by milkmaids.

The mermaid longed to return the sea, but the inhabitants of Edam didn't let her go. People flocked from all over the country to view the 'woman of the sea'. The residents of the powerful city of Haarlem heard about this wonder and requisitioned her. She learned to spin and lived there for many years.

In 1645, the Dutchman Casper van Wachtendorp wrote:

> *She cried like a dog, mainly in the middle of the night,*
> *Before returning to silence at first light,*
> *Fish, her own bait, she caught with her hands,*
> *Scraping off their scales first with her sharp teeth,*
> *Or if she happened upon a wigeon or water duck,*
> *She pulled off the feathers, and all the small bones.*

Anyone wanting to catch a glimpse of the fury should travel to Edam, where a stonemason has carved her into the facade of number 15 Jan Nieuwenhuizenplein. Two milkmaids with buckets on yokes carry the naked, wool-spinning mermaid between them.

The ancient Greeks feared the sea. They believed in Pontos, the sea god of storms, shipwrecks and drowning men. His hair and that of his wife Thalassa consisted of seaweed in which sailors could become entangled. Water nymphs sometimes came to the rescue of sailors in need, but more often they lured them to death with their seductive singing and seaweed sashes.

T. S. Eliot described the danger in *The Love Song of J. Alfred Prufrock*:

We have lingered in the chambers of the sea
By sea-girls wreathed with seaweed red and brown
Till human voices wake us, and we drown.

The same warning can be found in the fairy tale of Nitella and Alba. Long before the seaweed-covered woman was found in Purmer Lake, the seductive nymph Alba was spotted shrouded in her blonde hair on the shores of a more southern lake. Her gaze met with that of Nitella, the god of hair growth. She gestured for him to approach and whispered in his ear, 'I can't see your body, I can't see your face. I might fall in love with you if you didn't have such long hair everywhere. I would get tangled up in it if we went swimming together. I will become your lover if you cut your hair.' Nitella yielded to her strict demands and his hair slowly sank to the bottom of the lake.

When Alba and Nitella entwined and swam together, the supreme god suddenly roared: 'Idiot, you threw away your greatest gift for love. You are not worthy to be a god! From now on you will be bald and entangled in the hair that you have thrown away. And Alba, you have once again seduced a man into committing foolish deeds. That will not happen again, you must live on as a water plant.' And with

an enormous gust of wind the supreme god disappeared, leaving the lovers bewildered.

Within an hour, Nitella was swimming bald and naked in the midst of his fast-growing hair, which continues to multiply to this day. You find it in salt and fresh water and it is called seaweed. The white nymph lives on as *Nimphaea alba* – the water lily. In the summer, her white flowers enchant with their golden-yellow hearts and more. If you look at the large floating leaves, you will spot a remnant of her seductive powers: the foliage is heart-shaped.

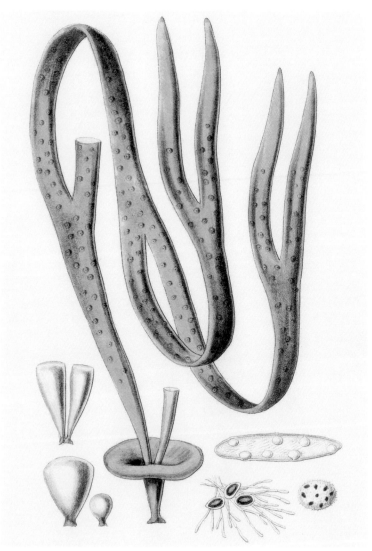

Oarweed originates from small horns that transform into miniature pointy hats when broken free on land.

6

Gramophone

AFTER A STORM, BEACHCOMBERS CAN INDULGE to their heart's content. The beaches are covered with treasures such as fish crates with 'Stolen from Whitehaven' or 'Stolen from Castletownbere' printed on them (each crate was simply knocked overboard and washed ashore), bits of smooth driftwood, a segment of a plastic palm tree, a dismantled lobster trap, thirty metres of tangled rope, water bottles filled with sand, caps that blew off, brushes without bristles, lids without handles, buckets without bottoms, a pink elephant baby walker, a section of fishing net with a single glass weight knotted to it, and a strange kind of witch's hat. The hat is no bigger than a fingertip: raven black and pointed, with a bent tip. At the bottom are two little upright posts. It is an enigmatic object. The discovery of that hat turns the beach into a vast sandy expanse upon which a tiny person lost something. The scale of the landscape has been turned upside down.

The hat turns out to be a shoot of *Himanthalia elongata* – thongweed. The young sprouts are edible and are also known as 'sea spaghetti'. These long dark strands can grow to a length of six metres. The seaweed has two stages of development. In the first year, the small bud-shaped

thallus attaches itself to the seabed in shallow water. In the second year, two thallus ribbons containing the reproductive cells grow. In the winter, once the reproductive cells have been scattered, the ribbons die and only the glassy green nodules remain. After a storm, you can often find entire forests of thongweed on North Sea beaches.

Displayed on my desk, the seaweed hats remind me of Thomas Edison's phonograph, and the gramophone that Brian Sweeney Fitzgerald, played by the legendary Klaus Kinski in Werner Herzog's *Fitzcarraldo*, took on board the *Molly Aida*. There is a beautiful scene in which the voice of Enrico Caruso reverberates across the Ucayali River, the aria slowly echoing back off the luscious riverbanks.

The black horn on my desk remains silent, but has since been joined by eight similar tooters. I would love to play on it Lee Patterson's *Pond Weed*, in which the growth of a hornwort plant in a pond near Manchester can be heard through thousands of oxygen bubbles. The bubbling forms complex rhythms. According to Patterson, each vibration is a separate bubble rising from the plant. The more light there is, the higher the frequency of bubbles around the hornwort plant, resulting in uplifting rhythms and variable tones.

In *From Strings to Dinosaurs*, musician Andreas Greiner places four transparent jerrycans filled with sea water on the strings of a piano in a completely darkened room. The water contains sea spark: single-celled algae that respond to vibrations by emitting flashes of blue light. Sailors have often reported similar bioluminescence. In thirteen minutes, the composition builds up according to the logic of cell division (2, 4, 8, 16, etc.) to a peak of light flashes, after which light and music slowly fade away.[13]

Kelp stipes lie stranded in one of the coves of Laimhrig nan Draoidhean. All foliage was knocked off in the winter storms,

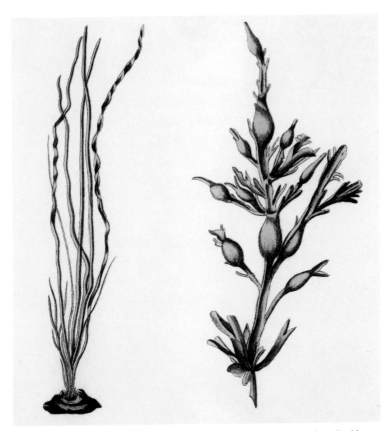

Fucus filum *waving on its podium alongside a* Fucus nodosus *dipped in liquid gold.*

rendering the seaweed no longer seaworthy. A thick fog closes in, turning the landscape into a concert hall. The *digitata* drum on the rocks. Fascinated, I listen to this onshore percussion band practising drumrolls for the next tattoo. If, as is often claimed, every seventh wave is higher and longer, I should be able to hear the rhythm of the sea in the drum. I sit down on a boulder just above the waterline and listen

carefully. New sounds seem to be added every minute; the surf changes into an orchestra pit. I listen to the whoosh of the mist particles, the soft waves that precede the flip of a large wave, the long unrolling of the sea, the end of the rising tide, the kelp at its feet gliding over other kelp and the bubbles in the sand after the water's retreat.

A few hours later, when the fog has cleared, the score to which I'd listened is spread out over the beach; a notation of seaweed, in which all chords are fully noted.

Dúlamán is the Irish name for channelled wrack (*Pelvitia caniculata*) and is also applied to folk songs praising the charms of seaweed. In 1976, the Irish band Clannad named an entire album after dúlamán and the song was also used as a melody in the computer game *Endless Ocean: Blue World (Adventures of the Deep)*. A *dúlamán* is often sung as a lullaby. The Irish word for seaweed may also be one of the first words an Irish child learns:

> *Oh gentle daughter, here come the wooing men*
> *Oh gentle mother, put the wheels in motion for me*
> *Seaweed from the yellow cliff, Irish seaweed*
> *Seaweed from the ocean, the best in all of Ireland*
>
> *There is a yellow gold head on the Gaelic seaweed*
> *There are two blunt ears on the stately seaweed*
>
> *The Irish seaweed has beautiful black shoes*
> *The stately seaweed has a beret and trousers*
> *Seaweed from the yellow cliff, Irish seaweed*
> *Seaweed from the ocean, the best in all of Ireland*

I would go to Niúir with the Irish seaweed
'I would buy expensive shoes,' said the Irish seaweed
I spent time telling her the story that I would buy a comb for her
The story she told back to me, that she is well-groomed
Seaweed from the yellow cliff, Irish seaweed
Seaweed from the ocean, the best in all of Ireland

'What are you doing here?' says the Irish seaweed
'At courting with your daughter,' says the stately seaweed
'Oh where are you taking my daughter?' says the Irish seaweed
'Well, I'd take her with me,' says the stately seaweed

Seaweed from the yellow cliff, Irish seaweed
Seaweed from the ocean, the best, the best
Seaweed from the yellow cliff, Irish seaweed
Seaweed from the ocean, the best, the best
The best in all of Ireland

Of all the seaweeds, rockweed or *feamainn bhuí* (*Ascophyllum nodosum*) seems the most suitable to use as an instrument to accompany this song. It can live for up to eight years and has a maximum length of one and a half metres. Large floating bladders filled with air grow along the long main axes. Each bladder represents a year of growth. In its dry state, you can pop the bladders like fuchsia buds. The sound they make is not loud, but muted. You could play it with four or more hands, a modest instrument that is worth mentioning and certainly deserves a place in the seaweed orchestra of the future.

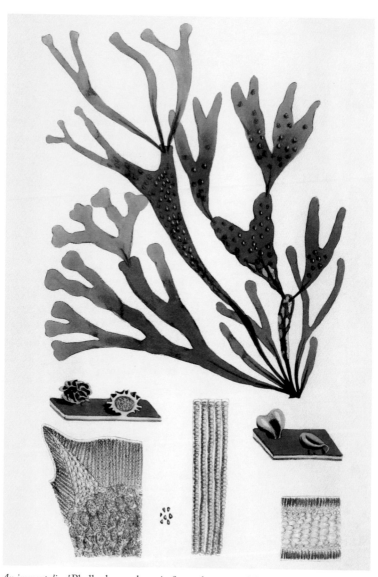

An immortalised Phyllophora rubens *in fiery voluptuous red does credit to its name.*

7

A Heady Scent

AFTER A STORM, THE SALTY SMELL of the newly beached algae floats above the island. The aroma lures me to the beach, where I fill my lungs and feel the green oxygen flowing straight through my airways to my brain. It is an elixir that unfortunately becomes intolerable a few months later.

In the winter, the sea pulverizes the detached weed. She smashes the fronds and stalks in the surf and against the rocks. From March onwards, crossing the mudflats means sinking deep into rotting seaweed. I hold my breath with every footstep. On beaches all over the world, the seaweed pulp gives off a stench in the spring. Passers-by pinch their noses and hold their breath in disgust.

In some tropical locations workmen are called in to remove the seaweed from the beaches. Where does all that algae go? 'We need to have a regional effort,' Christopher James, chair of the Tobago Hotel and Tourism Association, explained to the *Guardian*, 'because this unsightly seaweed could end up affecting the image of the Caribbean.' The fifteen member states of the Caribbean Community are even considering organizing a summit on the algae problem.

Mexico employs 4,600 workers to clean the beaches each year. The clean-up operation costs nearly $9.1 million. In the summer of

2008, the Chinese army sent hundreds of men to clear the beach off the coast of Qingdao of sea lettuce in preparation for an Olympic sailing competition. They stood there up to their calves in the gunk, raking away. They all wear black shorts, a camouflage shirt and a bright orange life jacket, while they don't even enter the water. I can imagine the need for life jackets and I suspect it is protocol, but perhaps it is the only way to stop the diggers drowning in the weed if they faint.

The excess of algae can be even more harmful to the animal kingdom. In the event of a plague, for example, fish suffocate due to a lack of oxygen and young sea turtles are prevented from leaving the beach by piles of seaweed. When cleaning up an excessive outbreak of seaweed, the animals living in it are also removed and erosion occurs on the beaches, after which the sand must be replaced from elsewhere.

Large kelp formations function as breakwaters and protect parts of the coastline, but some brown algae also create problems. The 'Great Pacific Garbage Patch', also known as the Pacific Trash Vortex, in the northern Pacific Ocean, is made up of millions of bits of plastic, which are partially crushed by wave movements and break into tinier and tinier pieces. Some species of algae bind to microplastic particles and transport them from the sea's surface (where other organisms can eat and potentially die from them) to the depths of the ocean, where the plastic becomes even more inaccessible and harder for humans to tidy up.

Virgil wrote, 'Nihil vilior alga' – there is nothing more worthless than seaweed – presumably referring to the decaying washed-up algae. Little can be done about the smell, but there is certainly something to be done about it appearing, says marine biologist Erik-jan Malta

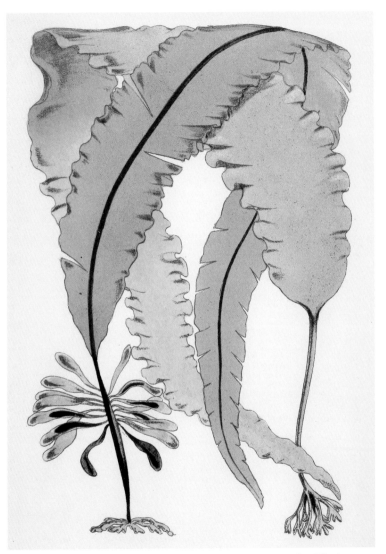

The intimate embrace of a winged kelp with a sugar variety in British Sea-Weeds, *described and drawn by Samuel Octavus Gray c. 1867.*

of the Netherlands Institute for Ecological Research in Yerseke. For four years he researched Lake Veere, a lagoon in Zeeland. It is one of the many polluted, nutrient-rich lakes bursting with seaweed. He wrote his PhD thesis on the 'sea lettuce blues'. The fast-growing sea lettuce grows into a mat and 'creates shade for itself in the summer'. There is sufficient light at the top of the mat, but not at the bottom, which causes the weed to stink. One of these mats is a world in its own right. Only the wind can break it open.

Worldwide, overgrowth of seaweed is causing more and more problems. Human-polluted, nutrient-rich water becomes filled with large clumps of weed or 'green soup'. Sea lettuce is the species that causes the most nuisance in shallow coastal water.[14] Not only in the brackish Lake Veere, but also along the coast of Brittany and in particular in Venice's smelly lagoon. Although the phenomenon of 'green tides' has been known for a century, there was little insight into its origin. Malta discovered that sea lettuce hibernates and buries itself in the bottom of a lake to survive the cold period.

A robust algae from Norway survived a stay of 530 days on the outside of the international space station ISS, *New Scientist* reported on 9 February 2017. Primitive plants are joining the space travel club, which also consists of bacteria, lichens and dozens of microscopic water bears (tardigrades). The extraordinary, robust green algae was discovered by German biologists in Spitsbergen, where it was able to withstand extreme cold and prolonged drought. This inspired the researchers to experiment one of the ISS's external panels. Exposed to the vacuum of space, the algae CCCryo 101–99 managed to withstand temperatures ranging from −20°C to 47.2°C and braved the persistent

cosmic and ultraviolet radiation that is blocked by Earth's atmosphere and is so strong it would destroy most terrestrial life.

The algae survived as encapsulated spores. They were dried on Earth in preparation for their journey. After sixteen months under harsh conditions, the experiment was returned to Earth. Within two weeks, the algae had shed their orange capsules and started to grow as if nothing had happened. Further research should show how exactly the DNA of the algae is adapted, allowing it to survive for more than a year and a half without a spacesuit. The experiment is part of a larger project about life on Mars. It will be a while before plants can be grown on the Red Planet. From the UV-absorbing pigments in the green algae, researchers hope to develop a cream that can protect human skin from the sun.

In the glass office of Rachel Culver, the librarian of the Scottish Association for Marine Science (SAMS) in Dunstaffnage near Oban, I watch a silent film from 1946 by an unknown maker about the Institute of Seaweed Research in Edinburgh, hoping to learn something about cultivating algae. The images, without subtitles or voice-over, appear surreal to a fledgling algologist like me. Machines grind pulp, an overlit hand holds a stopwatch, people put test tubes into a centrifuge, a laboratory technician in a smock climbs a ladder with a full measuring cup to pour liquid into a funnel, and someone makes something on a lathe, curls of metal shooting out all over the place. At the end of the film, a ship sails away and a man with a tie bows stiffly to the sea to pluck seaweed from the water. The typed note in the DVD box states that study of plant metabolism involved using a radioactive research method. A specimen of *Rhodymenia*

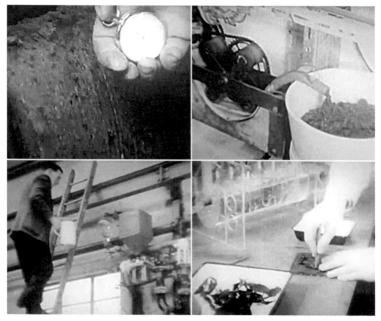

Four images from the 1946 film about Edinburgh's Institute of Seaweed Research.

pseudopalmata comes into shot briefly, the note says, but this doesn't solve the film's mystery.

One floor up in the same building, I have an appointment that same afternoon with Professor John Day, curator of CCAP, the international collection of cultivated algae and single-celled organisms, a collection with a special history. The living catalogue, as Day calls it, contains some 3,000 cultures, some of which are very old. The collection contains two specimens from 1889. Wearing white lab coats we enter the laboratory, which initially appears empty. 'To your immediate right are the dangerous species,' Day explains. He spreads his hand out on the refrigerator containing them and explains to me

the tree of life, the family tree of all known life forms already familiar to me from Ernst Haeckel's illustration in *Generelle Morphologie der Organismen* (1866).

We pass two students who are working with test tubes and spray bottles in a corner. Before we step into the temperature-controlled area, all the dirt is cleaned from the soles of my shoes by an adhesive mat that is strategically placed in front of the safety doors. There are four different rooms: one at 20°C, two at 15°C and one at 8°C. In the first room there is an old-fashioned brown machine, kept level by a folded piece of paper on the floor, that is shaking eleven glass flasks topped with aluminium lids. The *Chlorella vulgaris* cells are shaken day and night; it keeps them healthy and stops them from sinking. On the left, hundreds of test tubes stand upright in metal racks, filled with algae that are applied to the agar in a zigzag movement to spread them out as much as possible. It's a beautiful sight, all those luminous green lightning bolts in semi-transparent jelly. Some of the algae have continued to grow on the agar and have shot downwards.

Without Michael Droop (1918–2011) and German professor Ernst Georg Pringsheim (1881–1970), the collection that John Day currently manages would never have contained so many strains of algae. In 1938 Pringsheim, who was of Jewish origin, fled the Nazis with the start of the collection in a briefcase. He was taken in by the University of Cambridge, where he continued his work and, with the help of his colleague Droop and students, built up a national collection. Scientists exchanged cultures internationally. Schools could order the specimens as teaching material for the (then taught) subjects of morphology and anatomy.

Thirty years after Pringsheim's retirement, the laboratory was closed down. The freshwater algae moved to the laboratory of the

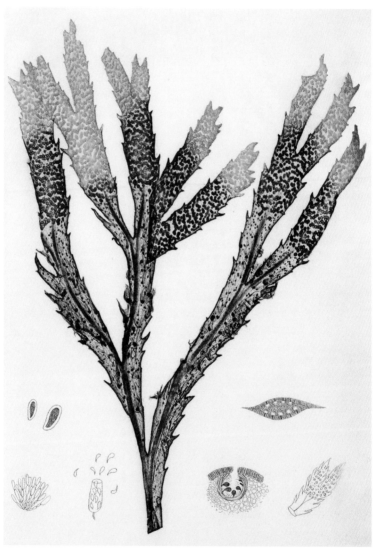

The height of seduction. This toothed wrack displays its reproductive organs at the tips of its branches. The corrugated tips drawn like sandpaper actually feel velvety soft.

Freshwater Biological Association in Windermere and the saltwater algae to Dunstafage. Seventeen years after the division, in 2004, the two collections were reunited. John Day says, 'I set off for Oban with the backup copies of the collection one day after the truck with the test tubes and other equipment had left. I've never driven as carefully in my life, I was terrified something might break along the way.' Day and the parallel collection arrived safe and sound.

'Do you eat seaweed?' I ask Day before we say goodbye. He shakes his head and says, 'My father did, he loved it. When he got old, I'd always take along a bag of dried dulse with me when I visited him. He'd sprinkle the plum-coloured shreds on a white, thickly buttered slice of bread, fold it in two and devour it eagerly.'

Lounging in a bathtub of warm water to which I have added a few strands of toothed wrack, the stench that algae can give off is almost unimaginable. My bathwater smells of seafood and the colour of the water is clear green as though I am lying in a large bowl of Japanese green tea with loose tea leaves. Seaweed stimulates blood flow. It promotes skin cell metabolism, detoxifies the body and restores moisture levels in the skin. After the bath, my whole body tingles.

Algotherapy and thalassotherapy baths have been offered in most spas for a few years now, but the tiled and sterile bathrobes seem thousands of miles from the rugged places where seaweed gains its vitality.

The legendary Chinese ruler Shennong, who lived nearly 5,000 years ago, is said to have invented the plough, and with it agriculture, and discovered the therapeutic effect of plants and seaweeds. According to Shennong, seaweeds were extremely suitable for

calming the nerves, combating pain, alleviating swellings and healing tumours. They also helped treat blockages, endocrine diseases, cysts and chronic bronchitis. Chi Han, as early as the fourth century BC, mentioned seaweed as a means to fight insects. Around the year 1200 the Italians Roger Frugardi and student Rolando da Parma wrote about the beneficial effects of dried or roasted seaweed on goitre.

The red seaweed Pink Paint Weed sticks to the rocks in a thin crust and sometimes grows among the roots of the kelp. The seaweed turns orange, red or purple, but once detached from its rock it soon fades in colour. The inhabitants of the Hebrides scraped it from the boulders and the alga, ground and mixed with egg yolk, was used as a medicine to treat diarrhoea.

Penobscot shamans from North America simmered dulse in sea water in a pan over a fire until it turned into jelly, and rubbed this gel on the chests of heart patients.

Passamaquoddy warriors from north-eastern North America carried bags of dried, crumbled dulse. They sucked on the chips at the first sign of fatigue.

In Talisker, a boy was cured of colic by placing a warm dulse pack, including its juice, on his lower abdomen. He changed the compress several times a day.

When a large handful of dulse is rubbed on the naked belly during delivery, the placenta arrives safely. The fresher the dulse, the more effective.

Dulse, eaten raw or cooked and consumed daily, is apparently an excellent remedy for scurvy. To remove parasites from wounds, the ashes of the burned kelp are mixed with salt water. By spraying this liquid on the wound and allowing it to dry, the parasites are repelled.

In Korea, you get seaweed soup on your birthday. This soup is actually intended for women who have just given birth. They eat seaweed soup for three weeks to regain their strength. You eat seaweed soup on your birthday in memory of your mother and the pain she went through, more than to celebrate.

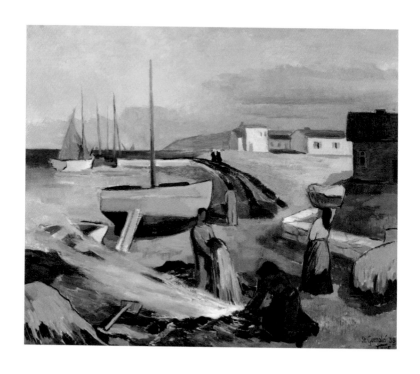

Tove Jansson's The Seaweed Burners, *painted on her travels in Brittany in 1938.*

8

Reaping and Gathering

I walked, a bygone summer day,
The sandy links of a sea-blown bay.

And there an old kelp-worker met,
Whose lone gaunt figure haunts me yet.

His hands, heaven's gift for daily needs,
Were gnarled like withered tangle-weeds.

The gentle strength of summer skies,
Long looked at, filled the old man's eyes.

He moved about upon the beach,
Wary of step and scant of speech,

And wore with aspects of renown
The beauty that is labour's crown.

Robert Rendall, 'The Kelpworkers'

UP UNTIL THE 1950s, wagonloads of seaweed were brought ashore by the thousand each year along the coast of France to extract the potassium needed for the soap and glass industries and for the manufacture of gunpowder. Some of the potash kilns cut into the rocks have been preserved and declared National Heritage. The long

narrow stone compartments in which the seaweed was tamped down and burned to turn it into compact ash blocks now lie empty in the landscape, like ladders into history. Around 1900, the thriving kelp industry was a popular subject in painting. The hard work, the packed wagons pulled by horses or donkeys and the smoke on the beach naturally created beautiful scenes. The canvases are usually dark in colour, brownish-green like wet seaweed and they shine excessively due to the varnish layer applied over the oil paint. Gauguin painted his version of the kelp workers in clear blue and green hues and placed the workers in the water, as flowing as the algae itself.

Paul Gauguin's Les pêcheuses de goémon *painted in 1888. The weed gatherers bend in the wind just as charmingly as kelp in water.*

In June 1938, the Finnish writer and artist Tove Jansson went to
Brittany, where she travelled on foot from village to village, painting
and sketching her impressions. Two of her best-known Brittany
paintings from that trip are both titled *The Seaweed Burners*. In a letter
to her parents, she describes the process:

*I came to the dunes beyond the village, where thick, billowing smoke
from vast numbers of fires was carried on the wind. I went up to one
of the fires, watched them working for a while and then asked if I could
help. They let me, but I could see they were thinking: 'crazy tourist! …
I proved them wrong, because I kept at it right up to midi, and carried
on after dejeuner until 3 o'clock when it was all done. And I shall go
there tomorrow, too, because I've seldom had such fun. – The seaweed's
piled up in huge rectangular heaps where it's been stewing all winter,
taking on a leathery consistency that the Bretons call 'teil'. I stood up
there in my swimming togs in the brilliant sunshine, throwing down
the seaweed, which was sometimes so compacted you could scarcely
prize off a single algae, and then the whole lot is carried to the fire,
which is laid over six square compartments in a row, penned in by flat
stones. It has to be tended non-stop – i.e. anywhere you see the red of
the fire you have to cover it over with the algae. Once the burning is
done, you're left with a sticky black mass that cools and hardens – the
stuff one used to find on the beach as a child and call coke. This is the
most important industry here apart from crab fishing, which I'm going
to try tomorrow afternoon – the solid iodine is expensive, costs about
60 fr. a kilo. I enjoyed running around in the smoke and 'covering',
and it was a beautiful sight: the women in black, the piles of gleaming
seaweed against the intensely blue sea with the sailing boats constantly
whooshing past. I shall do a painting of it later.*[15]

From 1735 onwards, kelp was burned along the coast of the Hebrides. The seaweed that grew around the Scottish island of Ulva was of the very best quality and raised the most money. The saying 'A golden crop surrounds the island of Ulva' dates from this time[16]. Landowners with fields bordering the sea made huge profits from the free kelp. The alga was harvested by poorly paid workers who had to pay rent to the same landowners with their wages.

Entire families went to the islands in the summer months to help bring in the kelp. Each family formed a team. Young women cut the weeds from the rocks with sickles. Older women and children carried the wet kelp in lobster traps to the drying place and the fire. Young and old men dried and burned the kelp. Soon there was a grain shortage due to the increase in population. Potatoes imported out of necessity provided little relief. The original islanders simply refused to eat them. From 1800, kelp prices plummeted and the industry collapsed completely. On an engraving made by British landscape painter William Daniell during his ten-year journey through the United Kingdom, a titanic cloud of smoke rises up from the rugged cliffs of Gribune-head on the Isle of Mull. Daniell most likely did not see these massive kelp fires with his own eyes. In 1815, the year he visited the Hebrides, the smoke plumes would have been a lot less high and more infrequent.

Sea grass or grasswrack has been growing for centuries on the mudflats around Wieringen in the county of North Holland. In the eighteenth century, the crop flourished mainly in the northern, saltiest part of the Zuiderzee. Due to the variable currents, the growth of the seagrass would increase or decrease. The sea dykes were maintained with

William Daniell published in 1817 an engraving of an impressive plume of smoke from the kelp burning at Gribune Head.

seaweed that looked like free-floating grass. It was fished out in July and August and transported by ship without any processing. The crew had to endure the smell and the steam it gave off onboard. The salt affected their eyes and the fishermen suffered from temporary blindness.

Objects on board were infected with the seaweed stench: silver turned black and copper eroded. Metal objects had to be covered with grease as a form of protection.

In a statement by Klaas Vregat, a former skipper from Hippolytus-hoef: 'The eyes of the boy who sleeps in the fo'c'sle are affected when the wind comes from the fore ... when the wind blows from behind, the skipper in the afterhold is troubled by it, and the servant who resides in the front deck suffers none of the discomforts.'[17]

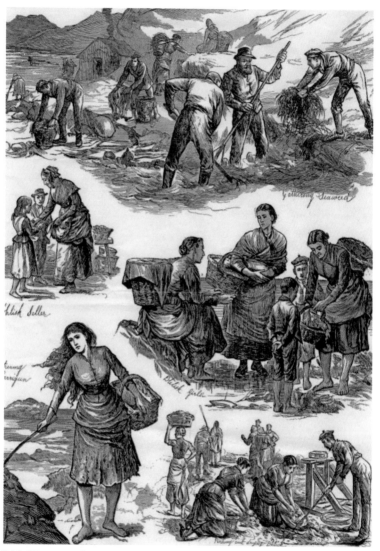

'Irish Distress: gathering seaweed for food on the coast of Clare', *from the* Illustrated London News, *May 12, 1883*.

After the storm tides of 1775 and 1776, seaweed was piled up two and a half metres broad and up to more than five metres high on the solid ground on the south side of the island of Wieringen to repair the dyke.

Seaweed was harvested in June with a scythe with a shortened blade. The reapers sailed to the site, jumped into the water, and each took to their pitch. When the seaweed began to rise above water due to the tide turning, the seaweed net with a lot of cork floats was cast. The reapers stood in the water wearing wading trousers, cutting and pushing the weed with the tips of the scythes to the right, causing it to flow back into the net. When the tide began to rise, the cutting stopped and the weeds were raked in with a weed hook and placed in the boat. A lot of water came off the soaking-wet seaweed, so that sometimes the boats had to be pumped out. In the harbour, the seaweed wagon would be waiting to carry the seaweed inland. There it was rinsed in fresh water. The ditches were full of it. Once it had turned black, it was pulled to the side and it was shaken briefly with a fork to get rid of the water. After that, it still had to be '*uut mekaar huzzeld*' – taken apart by hand until the strands were untangled. Especially with long seaweed, that was difficult work. After a good week of fermenting, it could be pitched and kept under a tarpaulin until it was weighed and pressed into 50-kilo bales.

In Cor Bruijn's *Sil de Strandjutter* (*Sil the Beachcomber*), a novel published in 1940 and set on the Dutch island of Terschelling, Sil sets his two young sons and daughter to work harvesting seaweed:

Seaweed is a valuable crop. It grows in the sea on nothing. God's might powers it. People only need to harvest it. Once it is dried and

pressed into bundles at Midsland, people on the mainland will pay an awful lot of money for it ...

Jan Kapteijn. He stands in the water up to his chest. They can see his head wagging back and forth above the glittering surface. He reaps. He is reaping with his scythe under water.

The current churns up the cut seaweed. Jan's helpers catch it in their spread nets, soon they'll pull it onto the boat with the claw ...

Sil casts the claw into the green sludgy matter, pulls large clumps to the side and begins to haul them up at the dyke.

The day advances. The sun burns. The salt water bleaches hands pale, wrinkled and rough ...

Zostera seagrass being harvested on the Dutch island of Texel, 1920s. Zostera was used to fill dikes, mattresses and pillows until 1932 when a disease abruptly finished the industry.

The piles on the dyke keep on growing higher. (…)

Seaweed, seaweed, seaweed, nothing else exists for him at this moment in the world. His face and his clothes are equally wet.

Sil and his children are barely distinguishable from the seaweed. They look green and drenched. At the end of the afternoon, Jan turns up again:

Jan! How many bales do you have, howwww mannyyyy ba-ales? Sil! A good five bales, I think, fi-ive ba-ales, Sil. I'm waiting for higher water! High-er wa-ter![18]

Fishing for weed followed weed cutting, in the period from late August to the end of October. The seaweed drifted onto the dikes, was caught in weed traps, divided up and a part given to the poor. Only the early lot of fished seaweed was rinsed; that which came later was dried after it had been rained upon. The last fished weed was left on the land until April, because it was impossible to dry it in the winter. This was known as *'stoppelwier'* – stubble.

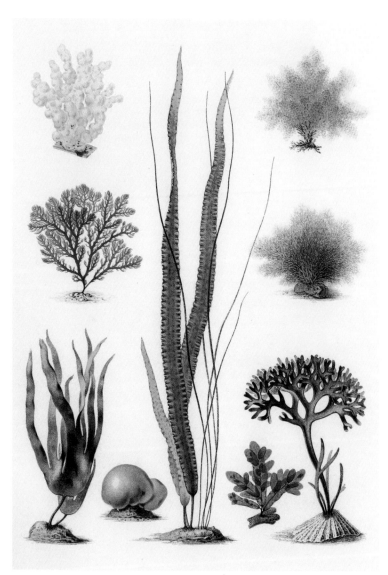

Each species of weed fixes itself to a preferred shell, stone or hollow in the rocks.

9

Truffle of the Seas

IN THE WINTER, WHEN THE GRASS STOPS GROWING, and there is less food for the animals on the fields, an excellent emergency ration is available in places near the sea. Along the coasts of Iceland, the Faroe Islands, Norway, Ireland and Scotland, farmers have driven their flocks to the beaches since times of yore. The sheep and cows belonging to my neighbour on Mull make their way to the tideline and chew on kelp stems at low tide. It remains a funny sight; the big bovine bodies on the beach, moving from one oarweed clump to the next, and sheep standing up to their bellies in the dark algaeic slush. When I approach they turn their heads to me, seaweed clamped in their jaws. Only when I'm a few feet away from them do they take flight, the nutritious stems still in their mouths.

Animals that live further from the sea also get their serving of iodine, minerals and antioxidants in the form of shredded seaweed added to their feed in winter. Along Europe's northern shores, seaweed was named after the animals that ate it. Bladderwrack is called *goémon vache* or *algue à vache* by French farmers. In English-speaking areas, cow weed is the name for *Alaria esculenta*. Dulse was fed to the horses (horse weed) and *Ascophyllum nodosum* (pigweed) to the pigs.

Feeding with seaweed increases the milk yield of cows, sheep and goats. Pigs are less fatty and have more meat; they find it easier to survive the cold and are more resistant to parasites. The seaweed keeps them in good condition, resulting in a shiny coat and healthy skin. Sheep get thicker winter wool with longer threads. They lose fewer lambs and the lambs grow faster. Seaweed can add value, too. The sheep on the Scottish island of North Ronaldsay, in Orkney, graze exclusively on the seaweed on the rocky seashore and are highly prized for their game-like taste. Seaweed also protects horses from colic, prevents hooves from splitting and makes mares more fertile. A free-range chicken foraging among seaweed has thick feathers, broods more easily and lays eggs with strong shells and large saffron yellow yolks. The red-brown beach flea lives below the tidemark and gives the eggs colour as chickens peck them out from under the seaweed.

Seaweed certainly has huge potential as animal fodder. The ploughing, sowing, mowing of a field in order to make hay seems laborious compared to its simple production. Grown in the ocean, seaweed needs neither fresh water nor fertiliszer. Fields currently used for growing crops to put into animal feed could be reclaimed to farm cereals, vegetables and fruits for human consumption.

There is an exciting possibility, too, in using seaweed fodder to combat climate change. Cows and sheep produce an alarming amount of methane when they belch or fart, accounting for nearly 15 per cent of the world's greenhouse gases (methane is about thirty times more destructive than carbon dioxide). But livestock that have particular seaweeds in their diets expel far less methane than animals fed on grass or general feed; this is due to its concentrations of bromoform – a compound that blocks the production of methane in ruminant animals.

Sheep feasting on seaweed on the island of North Ronaldsay, Orkney. They are fenced out of the fields, which are kept for cattle grazing.

In 2016, research from Australia's James Cook University revealed that the addition of just a small amount of *Asparagopsis taxiformis* macroalgae (less than 2 per cent of the total feed) reduced methane emissions in sheep by 50–75 per cent. In 2018, Iowan farmer Joan Salwen started putting the research into action. Preliminary results show a nearly 60 per cent reduction, far surpassing expectations.[19] The race is now on to find ways of producing *Asparagopsis taxiformis* – which is red-coloured in its sporophyte phases – at scale, close to where it will be needed, with maximum levels of bromoform. If that can be achieved, then the greenhouse gas emissions of cattle and sheep could be signifcantly reduced and livestock farming made greatly more sustainable.

Another large and polluting industry, salmon farming, can also benefit from seaweed. Growing seaweed close to the salmon cages has been shown to protect the fish from sea lice – a major problem for salmon farmers. And it's a circular benefit, as the nitrogen excreted by the fish helps the seaweed to grow.

In 1979, the father of ocean conservation, Jacques Cousteau, wrote: 'We must plant the sea… using the ocean as farmers instead of hunters. That is what civilization is all about – farming replacing hunting.'[20]

Former commercial fisherman Bren Smith has done exactly this and describes the benefits of ocean farming in his book *Eat Like a Fish*:

> *We have to adapt and learn from the changing seas. Not fight her but bow and step aside and let her rage and roll through. My crops are restorative. Shellfish and seaweeds are powerful agents of renewal. A seaweed like kelp is called the 'sequoia of the sea' because it absorbs five times more carbon than land-based plants and is heralded as the culinary equivalent of the electric car. Oysters and mussels filter up to fifty gallons of water a day, removing nitrogen, a nutrient that is the root cause of the ever-expanding dead zones in the ocean. And my farm functions as a storm-surge protector and an artificial reef, both helping to protect shoreline communities and attracting more than 150 species of aquatic life, which come to hide, eat, and thrive. Shellfish and seaweed require zero inputs – no freshwater, no fertilizers, no feed. They simply grow by soaking up ocean nutrients, making it, hands down, the most sustainable form of food production on the planet… The floating farm itself is simple: just anchors, ropes, and buoys creating a grid system.*[21]

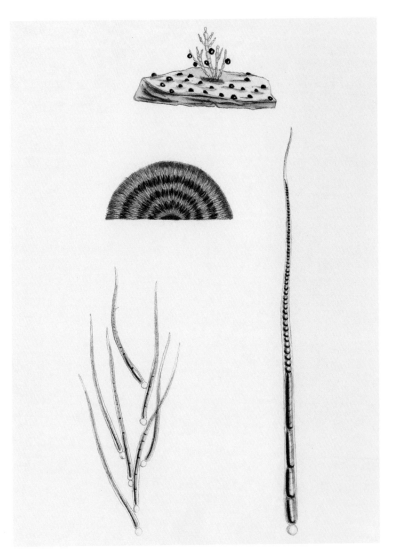

Some seaweeds such as Rivularia atra, *look like they were made by goldsmiths or glass blowers.*

Greenwave, Smith's bio-energy charity, is also working with a team of scientists and engineers to grow kelp as biofuel. According to the US Department of Energy, a network of kelp farms totalling an area half the size of Maine could grow enough biofuel to replace all of the oil in the US.[22] It is a promising-sounding estimate that, alas, has yet to become a reality.

For the land itself, seaweed is a good source of nutrients. Because seaweed consists mainly of water, it breaks down quickly, which makes it very suitable for use as a fertilizer. Along the coast, seaweed has long been used to improve the soil. The weed was raked up with great care, mixed with earth and then laid in rows to make raised 'lazy beds'. A great deal of manpower was needed for this, and it was undertaken in the autumn and winter months in shifts. The soil prepared for crops in this intensive manner yielded a richer harvest than fields that were simply ploughed. Farmers spread seaweed over their potato fields, over their turnips and over the grass used for hay.

In the autumn and winter, gardeners still fetch wheelbarrows full of seaweed to cover their beds with a layer of at least thirty centimetres. The soil benefits greatly and is enriched with iodine, potassium, nitrogen, phosphorus, amino acids and trace elements. Carrots are less afflicted by rust fly, flies stay away from beans and rhubarb starts sprouting earlier in the spring. It slows the growth of unwanted weeds around asparagus, cabbage and celery, which are originally coastal plants. In order not to disturb the naturally occurring salt levels in the soil, it is best to gather washed seaweed that has already been rinsed by the rain. Seaweed makes the soil porous because it binds together waste material. More air and water gets into the ground, which encourages worms to increase in number, ensuring the beds

are in good condition. During spring and summer, the crops in the vegetable garden can also be sprayed with diluted seaweed broth (seaweed that is mixed with water in a dark barrel).

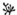

In Japan, China and Korea, seaweed has traditionally been treated with respect and is associated with health. In the past, the best weeds were reserved for the aristocracy. The oldest Japanese-Chinese dictionary, dating from AD 934 describes twenty-one different types of edible seaweed and also gives instructions for preparing it. Many of these recipes are still used.

The Japanese poet Bashō wrote a haiku on seaweed. Travelling by foot for two years, he noted in the summer of 1691:

failing health
chewing dried seaweed
my teeth grate on sand [23]

The sand which Bashō mentions was one of the criteria that the seaweed's quality depended upon. A batch of dried kelp could contain no more than 2 per cent sand and old or dead leaves were out of the question.

How precious seaweed was considered can be surmised from the various ways *Undaria pinnatifida* was dried in order to make the best *wakame*.

1. *Naruto wakame* is covered with ash from burning straw or ferns, spread along the coast and dried for a few days. After drying, it is washed and dried again. In this way, it does not discolour and it remains of the same high quality for many years.

2. *Yuniku wakame* is immersed in warm water until it changes
colour and then transferred to a cold bath. After the hard veins
have been cut from the leaves, it is dried for a few days. This
wakame is harder to conserve.

*Kubo Shunman painted the Kombu biscuits, baked and sold by Mrs Mayutama in Asakusa,
Tokyo; nineteenth-century.*

3. *Shioboshi* or *suboshi wakame* is washed in salt water and then dried. This seaweed is short-lived and must be consumed quickly after harvesting.

4. *Shioniuki wakame* is washed with fresh water to remove the salt, and hung over a tall pole.

5. *Midareboshi wakame* is immediately dried on sand after harvesting and without pre-treatment.

6. *Momi wakame* is rubbed together after washing with seawater, a process that is repeated seven times a day and ends with a drying day. This produces very soft *wakame*.

7. *Noshi*, *ita* and *suboshi wakame* is first washed with fresh water, then spread on bamboo or pine tables and dried for a few days.

Around Hokkaido, where kelp has been harvested since prehistory, the broth for *dashi* is made from it. The large seaweed is cut loose with a short scythe and taken to the beach, where it is dried and bundled together to be weighed, inspected and sold. The Taihō Code, a statute book from AD 701, obliged Japanese men to pay taxes in the form of precious goods such as silk, dye, varnish and the best-quality seaweed, which was sent to the court.

Nori is the Japanese name for a group of edible algae that grow on rocks in cold-water oceans. In Wales it is known as laver. Until 1600, *nori* seaweed was picked in the wild, dried and cooked as kelp or ground to a paste, but from the Edo period onwards seaweed was cultivated on a small scale and *nori* sheets were invented. These were made in the same way as paper: cooked, ground, sieved on standard-size screens of 22.5 by 17.5 centimetres. This is still the standard measurement for *nori*. The dried *nori* is sold in packs of ten sheets.

Traditionally, Japanese farmers planted bamboo stakes in shallow, muddy water, where the seaweed's spores collected around them. A few weeks later, these stakes were transferred to a river estuary to enable the seaweed to bloom. Latter-day farmers strung nets between the poles to allow *nori* seed to build up on them. This method was used for hundreds of years but remained small-scale, with the vast majority of seaweed sourced from the wild. Wild collection was the luck of the draw. Some years, large quantities of the thin filament-like spores grew into healthy, harvestable plants with long, green leaves; other years, they failed to settle. Since little was known about *nori*'s life cycle, there was no way to spore new seed to repopulate the depleted seaweed beds.[24]

Without Dr Kathleen Drew-Baker (1901–57), the Asian *nori* industry would probably not have flourished as it does nowadays. Around 1940, during her study of *Porphyra umbilicalis* in Wales, the British algologist unravelled the complex reproductive cycle of red seaweed in her own seaside lab which she and her husband built after the University of Manchester barred her from lecturing. No one in the UK at that time seemed interested in her discoveries. After the Second World War, Drew-Baker approached colleagues in Japan, who immediately realized that her research and conclusions, combined with new techniques of using synthetic material tied to bamboo poles, could make the commercial cultivation of *nori* possible. Back then, typhoons frequently swept away large parts of the crop and, because of the polluted water, wild sporing became increasingly problematic.

By uniting the forces of scientists and cultivators, production could begin in 1949. This made *nori* and sushi available across Japan. And so Kathleen Drew-Baker became the figurehead of the Japanese

Dr Kathleen Drew-Baker – acclaimed in Japan as 'Mother of the Sea' for her work that enabled the country to produce nori *at scale, and thus nationwide sushi.*

seaweed industry without ever visiting the country or seeing the results of her research. Every year on April 14, the Drew festival is held in Uto in honour of the 'Mother of the Sea', as Drew-Baker is called in Japan.

Today, almost 75 per cent of *nori* is produced in China, Korea, Indonesia and the Philippines, while 5 per cent comes from Japan and this remains the most expensive. Ireland, Norway, France and Iceland deliver the remaining 20 per cent.

Another seaweed that is cultivated intensively in Asia is carrageen or Irish moss, which agar is made out of. Agar is characterless, it has no taste, no smell and no colour. It binds better than gelatine and remains firm even when the temperature rises. Unlike gelatine, which is made from animal waste, such as skin, bones, cartilage and tendons, agar is purely an extract of red seaweed. It can absorb twenty times its own weight in water and hardens easily when soaked it in water and brought to the boil, even without a refrigerator. Agar contains a great deal of iron and calcium, while having a low calorie content. The binding force of agar is relatively short-lived, especially in substances with high acidity, such as chocolate, kiwis and spinach.

Until 1939, most agar was produced in Japan. There it is called *kanten*, which means 'cold weather air', referring to the fact that the seaweed is harvested in the winter months – freezing cold is essential to its production. *Kanten* was discovered by chance by an innkeeper in Osaka towards the end of the seventeenth century, when he threw away some left-over *tokoroten* (agar noodles eaten cold) outside in wintry weather. The next day he noticed that the cooked red *tengusa* seaweed (*Gelidium amansii*) had solidified. After a few days of alternating freezing and thawing, the *tokoroten* had turned into a dry white flaky substance. The innkeeper, fascinated

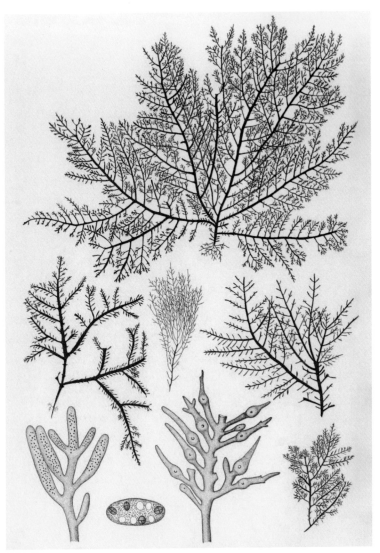

The feather-light Gelidium amansii *is dried after harvest, bleached, stamped, boiled in water, filtered and dissolved until it achieves the desired adhesive properties.*

by the phenomenon, succeeded in mimicking the freeze-drying process and set up the first *kanten* factory.

Agar is not only a powerful binding agent for puddings, ice cream and sauces, but also an excellent clarifying agent. Beer brewers use it to remove proteins and bitter substances, and fruit juices are also purified with them. As a thickener and stabilizer, it is widely used in creams, toothpastes and make-up. In the past, agar was used instead of a sticking plaster because of its water-absorbing properties. It is extremely effective at stemming blood flow. Dentists made moulds for dentures and prostheses out of it. Agar is also a tried and tested weight loss product, because it is so filling if you eat it.

The discovery of agar was also of revolutionary significance in bacteriology and it is still an unsurpassed medium for bacterial and fungal cultures. Fanny Angelina Hesse, wife of the famous bacteriologist Walther Hesse, suggested to her husband that he use agar as the basis for his microbiological work. A Dutch family who lived on Java had given her mother the recipe and suspected that it would be very suitable as a substance to breed cultures on in the laboratory.

In *Life of Pi* by Yann Martel, the starving Pi washes up on an island, after weeks spent floating on a raft at sea with Bengali tiger Richard Parker.

> *The smell of vegetation was extraordinarily strong. As for the greenness, it was so fresh and soothing that strength and comfort seeming to be physically pouring into my system through my eyes.*

What was this strange tubular seaweed, so intricately entangled? Was it edible? It seemed to be a variety of marine algae, but quite rigid, far more so than normal algae. The feel of it in the hand was wet and as of something crunchy. I pulled at it. Strands of it broke off without too much effort. In cross-section it consisted of two concentric walls: the wet, slightly rough outer wall, so vibrantly green, and an inner wall midway between the outer wall and the core of the algae … the centre tube was white in colour, while the tube that surrounded it was decreasingly green as it approached the inner wall. I brought a piece of the algae to my nose. Beyond the agreeable fragrance of the vegetable it had a neutral smell. I licked it. My pulse quickened. The algae was wet with fresh water.

I bit into it. My chops were in for a shock. The inner tube was bitterly salty – but the outer was not only edible, it was delicious. My tongue began to tremble as if it were a finger flipping through a dictionary, trying to find a long-forgotten word. It found it and my eyes closed with pleasure at hearing it: sweet.[25]

As Pi cried out for joy, he snatched up the algae around him and stuffed it into his mouth, both hands at a time. He ate until he'd carved out a trench around him.

I can't eat as much seaweed as Pi in one day. However, I did experience a similar kind of ecstasy when I discovered pepper dulse (*Osmundea pinnatifida*) in the mouth of the bay. One time previously, I had found and tasted its inch-long feathers on the other side of the island. In the sun it glowed an aubergine colour. Its fronds overlapped like roof tiles

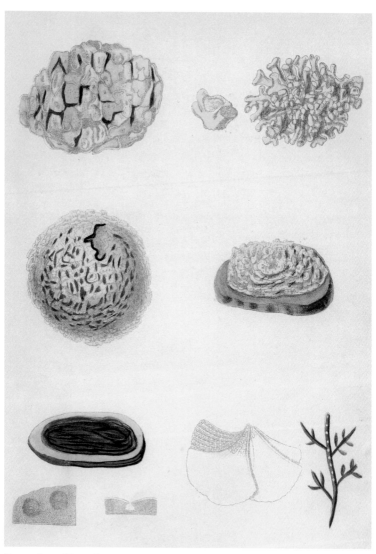

Seaweed's exorbitant characters. What's more, the majority of seaweed types on our planet remain unrecorded.

on the steep granite, making it difficult to pick. I tore off a few sprigs and held them to my tongue.

No other seaweed is as salty and spicy and has, at the same time, such a rich, mushroomy taste. Cooks often call it 'sea truffle'. These days, I consider it one of the most precious seaweeds for cooking with, even though nothing beats nibbling on a few raw savoury sprigs. Now that I know that, close to the shore here, a golden field of pepper grows, I always carry a pair of nail scissors in my bag so that I can harvest some by low tide without damaging the holdfasts. That would mean the end of my supply.

As well as Pi's surprise seaweed feast, there is Harry's Gillyweed snack in J.K. Rowling's *Harry Potter and the Goblet of Fire*. Just before the second task in the Hogwarts tournament, Harry is awoken by the elf Dobby, who tells him what the assignment involves.

> *'You has to eat this, sir!' squeaked the elf, and he put his hand in the pocket of his shorts and drew out a ball of what looked like slimy, greyish green rat tails. 'Right before you go into the lake, sir – Gillyweed!'*[26]

On the edge of the lake, Harry Potter takes a large bite of the stuff. He hurriedly chews as hard as he can on the seaweed, which is unpleasantly slimy and rubbery, like octopus tentacles. He stops wading into the lake once the water reaches his waist. The jeering of the spectators increases. Where are his magic powers? Then suddenly Harry can't breathe any more and feels a stabbing pain on both sides of his neck. When he claps his hands around his throat, he is shocked to find two large slits below his ears, flapping away... he's grown gills. His

hands and feet change into green flippers and he swims with powerful strokes through the forests of rippling, tangled black weed, where the Grindylows – or water demons – attack him.

What a mouthful of seaweed can lead to.

The seaweed industry is booming. Plans have been made to install a grid of seaweed seed lines in one of the bays around Mull to research the suitability of an 'ocean greens farm' on the island. In addition to a beneficial organic product, it would also create much-needed jobs. As long as too much hope isn't placed on seaweed. Very soon, a large food shortage will occur for part of the world's population. The seaweed industry, if locally managed and executed in an environmentally friendly manner, could contribute significantly to solving the problems caused by human beings. But it will only succeed if we map out all the contours with regards to cultivation,

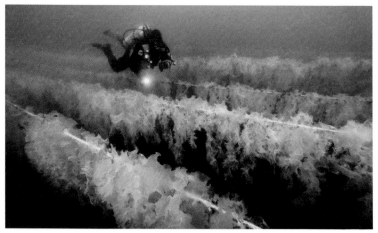

A diver inspects kelp being raised at an aquaculture farm off Vancouver Island, Canada.

harvesting, transport and consumption. As long as people don't dare to eat seaweed, scaling up makes little sense. When new interest only results in a haute (climate) cuisine tuft of seaweed or a pricey energy bar, our curiosity might be aroused and consumption shame briefly halted, but the planet doesn't benefit.

Seaweed initiatives, however, are emerging in all the world's seas. Just as this book was going to press, news was announced of a project to restore seagrass meadows to an area of 20,000 square metres off the coast of Pembrokeshire in Wales. Researchers from the World Wildlife Fund had discovered that seagrass (which is in worldwide decline due to pollution and dredging) absorbs CO_2 thirty-five times faster than tropical rainforest and can trap the carbon for millennia. 'We see seagrass as this wonder plant because of its ability to fight climate change, to help fish stocks, coastal communities and livelihoods,' said Alec Taylor of WWF. 'We need to expand hundreds of thousands of hectares of seagrasses, saltmarshes and other coastal ecosystems.'

This property of seagrass was, remarkably, a new discovery. However, seaweed congresses take place each year to share knowledge and to attract entrepreneurs. I joined one such conference, Seagriculture, at the port of Scheveningen along with 120 seaweed specialists from fifteen different countries. Over the year, I'd spent much of my time swishing around with seaweed in libraries, herbariums, along beaches and over rocks, and now found myself in the company of the like-minded for the first time. Seaweed tea was poured, seaweed snacks served, and seaweed findings exchanged. My thoughts strayed to a fertile seabed where gametes were being released and

merging together all over the place. The same was happening here. New partnerships were being formed to boost the emerging seaweed farming industry and to stimulate research into the possibilities of using seaweed as fodder and fuel, because fossil fuels, like oil, will run out fast. 'We must look for alternatives, and banish pesticides, antibiotics and plastics.' It sounded like a mantra.

During the lectures, I noticed how generous each speaker was in sharing their discoveries and calling for collaboration. These opportunistic initiates talked about sustainable investment with a flamboyance I found rather seaweed-like. Yet I missed seaweed itself there. Despite the numerous presentations featuring slides of waving sea lettuce and glistening blades of kelp, I wondered whether, beside all the potential being attributed to seaweed, one very important energetic quality wasn't being forgotten. The power and resilience of seaweed, this 'lower' plant species that manifests itself in so many wonderful forms. The seductive, sensual symbiosis of disparate species will, besides being a future raw material, hopefully spark wonder in us, speak to our imaginations and challenge the arts to embody her in image, sound, movement and space.

At the end of January, I wade through the surf on a quiet day, winged kelp around my ankles. I go deeper into the sea and see bladderwrack beckoning to me. Under the sea's surface it traces the curve of the bay. *At first I saw everything from below, and then I was algae.*

10

Recipes

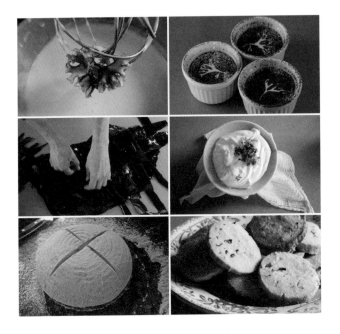

Duileasg Bree (Dulse and Potato Soup)

Serves 6 people
A handful fresh or half a handful of dried Dulse
1.7 l of milk or Oatly
225 g potatoes
2 tablespoons of parsley
1 lemon

Dulse is a dark red seaweed with wedge-shaped fronds. It can be eaten fresh in salads or washed and dried for later use.

For this simple soup, wash the seaweed well in running water, then soak it for one hour in cold water and strain. Put it in a large saucepan, cover with cold water and simmer gently for 30 minutes with the lid on. Drain well. Then beat in pepper, salt, butter and a little lemon or orange juice. Take the cooked seaweed, add the milk or Oatly and the potatoes (cooked and mashed) and simmer together for 20 minutes. Then beat well or liquidisze. Season to taste and add melted butter and lemon juice. Then beat the soup up again, heat and serve piping hot.

Pepper Dulse Hung Curd

Makes one mozarella-sized ball
4 g fresh pepper dulse (in small sprigs)
300 ml Greek yoghurt

Pepper dulse (Osmundea pinnatifida) *is a small algae that ranges in colour from yellow-orange to dark red.*

Place a colander or sieve in a pan. The sieve must not touch the bottom of the pan. Hold a cheesecloth (or muslin) under the tap, wring out and place the damp cloth in the strainer. Now pour the yoghurt into the cloth, add the pepper dulse and stir, knot together the tips of the cloth and stand the sieve of yoghurt in a cool place for at least 8 hours.

Once all the water has drained from the curd mixture, squeeze it gently into a tight ball. Unwrap. Roll the ball out of the cloth onto a plate and decorate it with a sprig of seaweed. Spread on crackers, toast or oatcakes and enjoy the intense mushroomy taste.

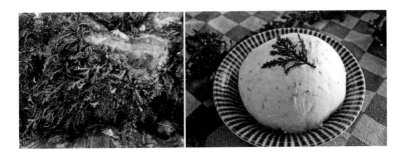

Rockweed Bread

500 g white flour
1/3 strand (30 cm) of rockweed/knotted wrack (*Ascophyllum nodosum*)
1/4 teaspoon yeast
450 ml water

Strands of rockweed can grow to a metre long and can live for years; never cut away the entire length, but only a third. Dry the seaweed slowly in an oven at 40°C until it is crispy.

Make the dough at least 7 hours before baking the bread. Mix the flour, yeast and finely ground rockweed in a bowl. Using a spatula, mix in the water in a couple of quick strokes. You should now have a somewhat sticky mass, something in between dough and batter. Now put the covered dough in a cool place. Around 15°C is fine. In many homes, this is the average temperature at night. If you make the

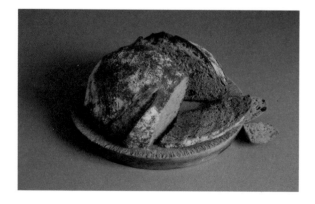

dough in the evening, it will have risen nicely by the morning. Leave covered for as long as possible and heat the oven to 230°C. Flour your worktop generously and sprinkle a few crystals of coarse salt on it.

Now tilt the bowl and scoop the dough onto the flour. Hands covered in flour, fold the dough once or twice; the less you touch it, the better. Lift it up and place it with the folds facing down in the middle of a baking tin, or Dutch oven if you have one. Make a deep cut along the top with a sharp blade and bake for about 30 minutes until crusty. Remove from the oven, place on a cooling rack and let the steam evaporate before you cut it.

KNOTTED WRACK

In the Chinese supermarket Toko Dun Yon, at the intersection of the Stormsteeg and the Zeedijk in Amsterdam, I find a 200 g packet from the Golden Lion brand labelled 'Dried Seaweed Knot' in the Asian vegetable section.

The English also call *Ascophyllum nodosum* knotted wrack but this looks to me more like sugar kelp (*Saccharina latissima*), given its white coating. To make things even more linguistically confusing for me: the related brown seaweed *Laminaria digitata* is also sometimes called a knot in Dutch! At home, I shake out the bag on the table and wonder if the matte green knots have been tied by far-away human hands or a machine that can cut and tie these slippery strips.

It's odd: one of the things that makes harvesting seaweed so difficult is that it gets tangled and knotted. Why are people knotting it?

On the internet I find a recipe for a traditional Taiwanese salad which lists precisely this seaweed as an ingredient.

During the cooking, I think of my grandfather, who put a knot in his handkerchief to remember something. If every knot in the pan represents a thought, then this salad might be an excellent remedy for memory loss.

The recipe recommends it not be served until the next day. I invite my neighbour Judy, who is always up for an experiment, to join me, and only when she's here do I understand the logic behind the knot. The knot allows the dish to be shared out equally, six knots per person, and more importantly it allows you to get a grip of the weed while you're eating it. However, even after this simple discovery, I can't help thinking about the things I'll forget as I chew apart each knot.

Taiwanese Knotweed Knots

Serves 4
12 seaweed knots
2 teaspoons sunflower oil
3 finely chopped cloves of garlic
2 tablespoons white vinegar
1 teaspoon sugar
2 teaspoons soy sauce

Soak the knots in water for 20 minutes. Heat the oil in the wok on medium heat until it begins to smoke, and fry the seaweed for a few seconds. Then gently mix in the chopped garlic until it turns

light brown. Add the rest of the mixed ingredients and cook for 2 minutes. Put the knots in a tray, arrange them all lengthwise, pour over the liquid and allow to cool. Close in an airtight container and allow the marinade at least 8 hours to soak in. The knots can be kept for at least a week in this way.

The knot-like oarweed seedlings were traditionally used in Scotland in sauces for cooking poultry, but I prefer to prepare the longer parts of the weed the way chef Luuk Langendijk does.

Whenever you are near a fishing port or a market selling fresh mackerel, oysters and oarweed, you can treat four people to this delightful dish in which the three different sea dwellers are in their element in broth – an absolutely delicate combination that caresses the taste buds. The sea has never tasted so pure and fresh.

Mackerel with Oarweed

Serves 4

200 g raw mackerel filet
salt and pepper
1/2 grated lemon rind
olive oil

Oyster mayonnaise
4 oysters freed from their
shells
1 teaspoon fish sauce
2 teaspoons lemon juice
1100–200 ml rape seed oil
salt and pepper

Crispy seaweed
100 g fresh oarweed or
 sea spaghetti
sunflower oil for frying

Pickled onion
1 medium-sized sweet white
 onion
100 ml red wine vinegar
100 ml beetroot juice
100 ml water
1 sprig of taragon
salt

broth
(make this the day before)
1 kg ripe tomatoes
100 g dried kelp
1/2 teaspoon vinegar, salt

Cut the fresh mackerel fillet into small cubes with a sharp knife. Grate some lemon zest over it and gently shake the fish with some pepper and salt. Store the cubes in the refrigerator.

Put all the ingredients for the oyster mayonnaise except the oil in a bowl and blend them with a hand mixer into a smooth puree. Now slowly add the oil until the emulsion binds with the oyster puree and becomes a thick mayonnaise.

Heat the oil to 165°C. Rinse the oarweed or sea spaghetti until it tastes slightly salty and dry the seaweed well between two cloths. Fry until it is crispy and stops bubbling.

Peel the onion and cut into thin strips. Heat the vinegar, beetroot juice, water, salt and tarragon in a saucepan until boiling. Add the onions and stew for one minute. Let the onion cool and remove from the liquid. Cut the tomatoes as small as possible and bring the pulp to a boil. Add the kelp, vinegar and salt and allow to cool slowly.

Pour everything into a bowl and put it in the freezer. The next day, thaw the block of ice. Sieve the broth through a thin tea towel or coffee filter so that the broth becomes clear and all solid components remain in the filter. Taste again and, if necessary, season with salt and pepper. Divide the mackerel over four deep plates. Add a spoonful of oyster mayonnaise to each plate. Arrange a few pieces of red onion and some crispy seaweed. Pour the cold broth into a jug and pour it over the plates at the table.

FISH IN A SEAWEED COAT

1 large fish
500 gram fresh or pre-soaked *kombu*
 or sugar kelp (*Saccharina latissima*)
cocktail sticks
1 lemon

Preheat the oven to 160°C. Descale and gut the fish. Cover a tin with baking paper, spread out the sugar kelp or *kombu* on it and wrap the fish as follows. Start with the torso. Lay the fish diagonally across the widest part of the seaweed and wrap up the fish. Pin it with two or three cocktail sticks. Try to fold the seaweed as closely as possible to the fish and secure it with cocktail sticks along the sides. Cook the fish for 15–20 minutes in its seaweed coat. Serve with lemon slices and unwrap at the table. The seaweed becomes deliciously crispy and is also part of the dish.

Oystercatchers like to build their nests in seaweed. They are well camouflaged against the weed with their black heads and backs, but don't seem much inclined to hide. When you enter their territory, they swoop down shrieking loudly, or play lame, to lure you away

from their hatch. When it comes to nest-building, they show little ambition; a shallow pit in the seaweed suffices. You can't really blame them. The sand-coloured eggs can't roll away and blend into the dark algae due to their black speckles. In the spring, I twice stumbled over a nest of three eggs that I narrowly avoided by jumping to one side. In China, the nests of the Java swift are eaten as a delicacy. I prefer to stick to the variant below.

SEA NEST

100 g dried kelp
50 g black or red and white rice
1 large parsnip
1 lime
butter

Cook the mixed rice. Cut the kelp into long thin strips and braise gently in a lump of butter for about 15 minutes. Cut the parsnip very thinly along the length of the root and fry the strips until crispy. Do not let them turn brown or they will lose their sweetness. Spoon three or four balls of rice onto the plate and arrange the kelp and the parsnips into a nest around it. Serve with a few drops of lime juice.

Carrageenan Cream

Serves 6
300 ml double cream
A handful (7g) of dried carrageenan (Irish moss)
40 g sugar
300 ml milk
1 tablespoon each of flaked chocolate and cocoa powder
1/4 teaspoon vanilla essence

Fifteen miles as the crow flies from Knockvologan, the MacGillivray family have survived for many generations as shepherds and crofters atop the imposing basalt formation Burg. In the Balevulin archives, I browse through a copy of the recipe book kept by Chrissie, the MacGillivrays' oldest daughter, who lived from 1898 to 1989 and was known on Mull as an excellent cook and an enthusiastic spinner and knitter. She dyed her wool with local plants and went around in her own self-knitted jumpers and cardigans. If you walked past her house to the fossilized tree at the bottom of the cliff, she'd make you a cup of tea on the way there and back. The MacGillivrays were completely self-sufficient. Among the instructions for making soap, hare pie and

bone soup (use either fresh or dry bones but do not mix them), I find Chrissie's recipe for a cream made with Irish moss that she must have cooked regularly. In an interview recorded by Moràg McColl, spinning and in her nineties, Chrissie says, 'We were down by the fossil tree … gathering carrageenan … the boys were always gathering whelks there. Carrageenan for pudding – seaweed, it bleaches white. We used that for pudding you see, by itself with nothing else. It tastes a wee bit of the sea, good for the stomach and heart, aye. They had everything, they made use of everything [back then].'

THE RECIPE

First, whip the cream until stiff. Set aside six sprigs of carrageenan. Add the rest of the seaweed and the sugar to the milk in a saucepan. Bring the milk to the boil until the liquid solidifies on the back of a spoon. Keep stirring. This takes about 15 minutes. Remove the seaweed and gently stir the whipped cream with the vanilla essence. Leave the carrageenan cream to set in a cool place. Top with either chocolate shavings or put a sprig of carrageenan on top of each pudding, sieve the cocoa powder over it and then remove the sprigs to leave a seaweed pattern.

Ulva linza was given an appropriate but somewhat unappetizing name in Dutch – *darmwier* (intestine weed). It can grow into thick clumps in the summer and is sometimes mistaken for a seal or loose green raft. It is also known as *'flap'* and grows on mudflats, at the foot of sea dykes, on quay supports, jetties, pontoons and mooring posts, on mussels, on the beach, around anchor ropes and under ships that stay in the same place for a long time. *Ulva linza* only lives for a few weeks. Fried in butter, it transforms magically into messy crisps and, because it is fairly sweet, if you use it in pastry you should reduce the amount of sugar you use.

Mermaid Confetti

Makes about 20 small biscuits

2,5 tablespoons fresh or pre-soaked sea lettuce
 (*Ulva linza*) or dulse
125 g slightly salted butter
50 grams caster sugar
180 grams white flour
1 egg yolk

Preheat the oven to 180 °C. Cut the butter into small chunks, mix it
with the caster sugar, the egg yolk and the seaweed shreds, and sieve
the flour over it. Knead the dough thoroughly and make a roll 25
by 4 cm. Wrap it in a damp cloth and lay to rest in the fridge for 30
minutes. Cut slices of 1 cm and use a fork to press a trident shape deep
into each biscuit. Spread the biscuits out on a baking tray covered in
baking paper and cook them in a preheated oven for 8 to 10 minutes
until they turn golden yellow.

II

Portraits

Hen Pen / Mossy Feather Weed

Bryopsis plumosa

Vederwier / Federtang / Algue plumeau

Hen Pen is a delicate feathery green seaweed. Its rounded stipe (stem), no thicker than the hair of a horse appears rather naked. Towards its tip the weed has regular, flattened feathers. It develops two-dimensionally: the side branches are arranged on the same plane and originate opposite to each other. They get shorter and shorter towards the tips. The female plant's thallus is bright green in colour. The male plant is a more yellowy green. Both are shiny.

Hen Pen is remarkably flexible and grows to around twelve centimetres on average. It uses just a few holdfasts to stick to its base. It hides away in rockpools under other more substantial algae. One old English field guide describes it as 'shy' which is well observed. As soon as you approach it under water, it bends away from you.

Hen Pen has spread across the Mediterranean, Atlantic and the North Sea, almost to the German archipelago Helgoland. It remains permanently under water in calm spots and beneath overhangs. It grows along the banks of the western part of the Baltic Sea, together with seagrass.

Aquarium-owners often complain about Hen Pen but it doesn't care, it carries on growing as rampantly as it likes.

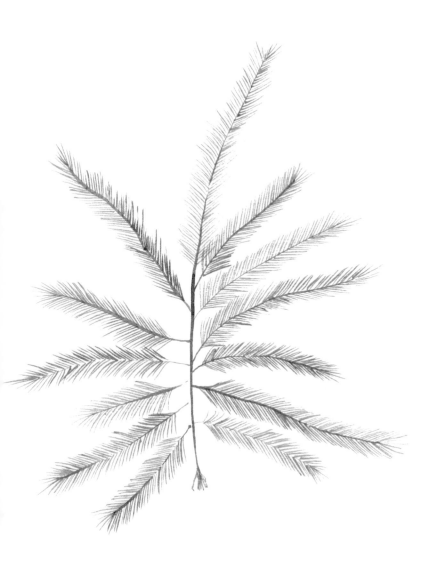

Green Hair Weed / Flax Brick Weed

Chaetomorpha linum

Drahtalge / Visdraad
Crinière flottante

Green Hair Weed is a delicate stringy green seaweed. One string consists of a chain of contiguous cylindrical cells which are twice as long as they are wide and rejuvenate from the base. Each individual strand remains unbranched. Despite their thinness of just a few millimetres they are fairly stiff. The longest strands measure forty centimetres. The seaweed is a clear green colour, sometimes almost pale blue. Old plants can turn yellow.

The weed has a modest holdfast and grows mainly on sand along the tideline or on mudbanks in shallow, sheltered waters in the Mediterranean, along the Atlantic Coast and up to the Baltic. The weed can continue growing without solid ground and floats around. Washed-up specimens provide shelter for tiny shrimps, shore crabs and mud snails. In the spring, the weed has a high iron, sugar and vitamin C content.

In the Netherlands, hair weed is called '*visdraad*' or 'fishing line'. The name must have come about just after the Second World War when the first knots of plastic wire washed up on the beach. In 1947, *The Art of Pike Fishing*, Jan Schreiner described a 'trace' (lower line) made of nylon 6 (24/100 mm): a transparent glassy wire. He must have been one of the first people to use artificial fishing lines because 'fibre 66' wasn't patented by chemist Wallace Carothers of the American firm DuPont until 1938. The commercial name *nylon* evolved from 'norun', 'nuron', 'nulon' and 'nilon'.

Green Hair Weed is also used for the benefit of fish and much used in aquariums to clean the water of nitrates and regulate pH levels.

Sea lettuce

Ulva lactuca

Zeesla / Laitue de mer /
Meersalat

Bright green sea lettuce catches the eye among the dark brown and red seaweeds. Its leaves can be rounded or rather irregular in shape, sometimes growing into lobes and reaching up to a metre in diameter. They are paper-thin and stiff to the touch, but tear easily. When the seaweed washes up, its leaves are usually terribly crumpled. Submerged in water, you can unfold them and then smooth them out on your palm like the foil of a giant Easter egg.

A sea lettuce's thallus is just two cell layers thick and it secures itself with a suction cap that often goes unnoticed below the short stipe. When the seaweed breaks away from its substrate, it lives on for quite some time.

Sea lettuce occurs in all seas in the transitional zone between coast and deep sea. It is extremely tolerant to temperature changes, fluctuations in salt levels and can tolerate a lot of pollution. Often, sea lettuce is the first algae to re-appear in a disturbed area – for example, after an oil spill.

Sea lettuce is an annual, fast-growing species. One gram of fresh sea lettuce can fix six hundred micrograms of nitrogen. Given this property, it plays a leading role in water-purifying ponds in and around salmon nurseries. Sea lettuce is already being used to purify the waste water from biogas installations.

Peacock's tail / Turkey feather

Padina pavonica

Trichteralge / Pauwenstaartwier /
Padine queue-de-paon

Although small, Peacock's Tail is one of the most memorable brown
algae. It looks like a beautiful peacock tail without eyes. The olive-brown
to ash-grey thallus fans out from the almost invisible holdfast. Brown
and olive green concentric bands of three to ficve millimetres thickness
alternate along the outsides. These colours are slightly obscured by calcium
carbonate. Deposits form on its surface, powdering the seaweed in silver.
On the inside, Peacock's Tail often turns lime green and feels somewhat
slimy, like many brown algae. The seaweed's hem curls inwards and has
fluffy white eyelash-like hairs.

Peacock's Tail is an annual. The thallus can grow up to ten cenimetres
and dies in the autumn. The following summer it appears in the same place,
often in clusters.

It adheres to porous surfaces, loose limestone, shells, coral reefs up
to twenty metres deep and can spread widely along sheltered coasts. It
tolerates great temperature differences and occurs in the North East
Atlantic from Ireland to the Canary Islands and West Africa and is found
in the Mediterranean, Black Sea and Indian and Pacific oceans. Along the
British coast, the species is in decline and decreasing by the year.

Padina pavonica is used in cosmetics to hydrate the skin.

Bladderwrack

Fucus vesiculosus

Blasentang / Blaaswier /
Chêne marin

Bladderwrack originates from a skinny thallus that is attached to the
substrate with a large adhesive disc. The leathery thalli have a clear central
vein and are forked regularly. The round air bladders usually grow in pairs
on either side of the vein and are reminiscent of bulging toad's eyes. These
air bladders allow the weed to float, as a result of which it can get more
light. In areas with stronger waves, the characteristic air bubbles may be
missing from the fleshy section. The fronds don't have any indentation. At
the ends of the thalli, tufts of hair grow from shallow pores. Per strand,
bladderwrack grows to around two centimetres wide and twenty to seventy
centimetres long.

Bladderwrack grows on the northern shores of the Atlantic and Pacific,
as well as in the North Sea and the Baltic, often as a band just below
Toothed Wrack. Bladderwrack also strongly resembles Spiralled Wrack.

In the summer, the seaweed reproduces via its yellowish-green swollen
fruits which have a bobbly surface and contain a jelly in which the sex cells
mature. At rising tide, they are dispersed; the sperm cells are attracted to
the egg cells. A new thallus develops from a fertilized egg.

Fishmongers like to lay bladderwrack on ice to keep their wares fresh
and to give the illusion that the fish has just been taken out of the sea.

English wool weavers called it Red Wrack or Dyers Wrack and used
it to dye wool a pale yellow. Many healing powers are attributed to
bladderwrack.

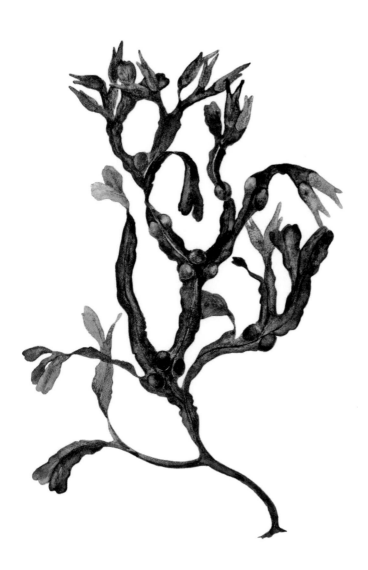

Sugar kelp

Saccharina latissima

Weather weed / Sea belt / Devil's apron / Zuckertang / Suikerwier Baudrier de Neptune

Sugar Kelp develops characteristic, large, chestnut-brown, elongated leaves of a regular width with highly corrugated, sometimes even deeply pleated, edges. They can grow up to three metres long and thirty centimetres wide and narrow slightly towards the tip. Sugar kelp doesn't have branches and has no central vein. The short sturdy thallus attaches itself with strong claws to the rock. It is one of the species that can form kelp forests, but it isn't keen on waves and occurs in the northern Atlantic, from the cold Barents Sea to the northern shores of the Spanish region of Galicia.

During the course of the year, the *sori* in which the spores develop, appear on the surface of the leaves. These grow into asexual plants upon which the sex cells originate. The egg cells attract the spermatozoa and the fertilized ova, then develop into sugar kelp thalli.

Kelp is often sold as *kombu*. It contains the sweetener mannitol, which appears in the summer as a thin layer of white crystals on the leaves when the weed dries out. Due to its high sugar content, it is highly suitable for producing alcohol.

In the olden days, this seaweed was used as a barometer. People hung the 'poor man's weatherglass' on their walls. If the foliage remained stiff, then this indicated dry weather for the next few days. When it became soft and limp, there was moisture in the air and a great chance of rain.

Oarweed

Laminaria digitata

Tangle red ware / Sea girdle /
Vingerwier / Goémon de coupe

Oarweed has broad chocolate-coloured, deeply indented leaves that appear to be made up of numerous fingers (the Latin word *digitus* means 'finger'). The seaweed is so shiny, it reflects the sky and feels soft and slippery. The smooth stem is thick and flexible, oval in cross-section and adheres to rocky surfaces with a sturdy holdfast. Oarweed can grow up to two metres, while the frond part can grow up to one and a half metres. The clearer the water, the larger the oarweed and the more fingers. In winter, reserve nutrients stored in the old leaves are returned to the stipe. New leaves grow with the increase in daylight in the springtime.

The leaves of *Laminaria hyperborea* look very similar to that of oarweed, but its stem is rougher, round in diameter and fragile. Oarweed can live for up to six years. It often spreads along the rocks, creating underwater meadows, especially in places that rarely stand clear of the water. Oarweed's reproduction is very similar to that of the other *Laminaria* species. The sea urchin *Strongylocentrotus*, which is proliferating due to overfishing, likes to eat oarweed and grazes on kelp forest until the seabed is bare.

Oarweed flourishes in strong sea currents along the North Atlantic coast of Iceland and from Spitsbergen to Spain and the Canary Islands but also in the North Sea and the Baltic Sea.

In the eighteenth century, oarweed was burned to make potash for the soap and glass industry, and later, in the nineteenth century, iodine was extracted from it. It is now used as a biological fertilizer. In concentrated form as an alginate, it is an important component of toothpaste and acne or pimple ointments.

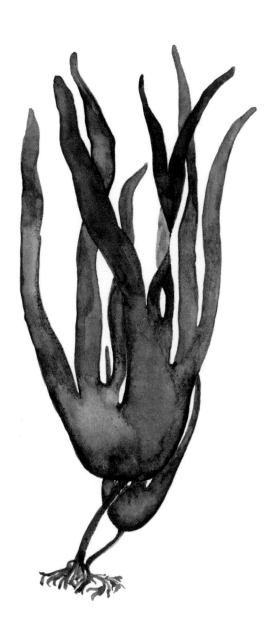

Toothed Wrack

Fucus serratus

Serrated Wrack / Sägetang /
Gezaagde zee-eik / Varech dentelé

Toothed Wrack is very similar to bladderwrack and also has a large flattened thallus that attaches to the seabed with a disc holdfast on a short stipe. The thalli are characterized by a central vein and are regularly branched and flattened at the ends. The leaf edges are serrated and don't have floating bladders. Toothed Wrack has numerous minuscule pits at the tips of the fronds from which tufts of hair stick out. The thallus measures about two centimetres in width and is about half a metre long.

Toothed Wrack has a large distribution area and grows in slightly sheltered areas along the entire coast from Norway down to Portugal. It often forms a separate belt in the lower zones of the intertidal area called the '*Fucus serratus* community'.

In the winter months, it reproduces via fruiting bodies that are bobbled on the surface and contain a jelly in which the sex cells mature. Unlike bladderwrack, the fruiting bodies are inconspicuous.

Colony-forming hydroid polyps *Dynamena pumila*, reminiscent of clumps of moss, often make their home on Toothed Wrack. The sea snail (*Littorina fabalis*) also likes to live on it. This gastropod mollusc deposits eggs on the thalli but does not feed on the wrack. Instead it eats the microscopic algae that grow on it.

Raw materials for the production of cosmetics are obtained from Toothed Wrack. It is also a key element in Thalassotherapy.

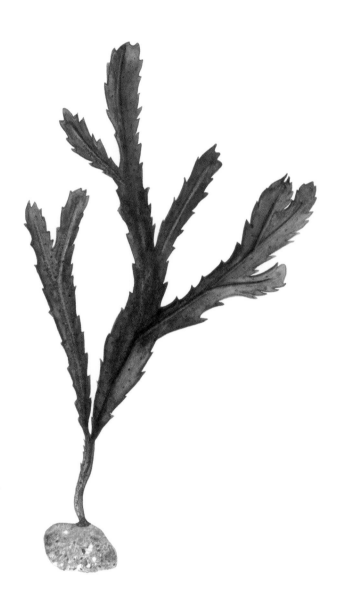

Purple laver

Porphyra purpurea

Tough laver / Purperwier /
Purpurtang laver

Purple Laver resembles a loosely folded napkin made of a soft, slippery fabric. The corrugated foliage changes colour with the seasons: from dark purple in the late summer, to reddish brown, then greenish purple, to olive green at the end of winter. It grows to about sixty centimetres in size. The silky purple laver is made up of a single layer of cells, which is thin but strong. It adheres to hard surfaces with a navel, an adhesive member in the middle of the foliage. The laver is uncovered at ebb. The thalli dry into piled-up membranes and look a bit like a colony of sleeping bats. When the tide recovers the laver, the purple pleats seem to unfold immediately.

The seaweed is fond of light waves just below the tideline. It grows on rocks, rocks, dykes, breakwaters, wood, barnacles and shells in the surf.

Purple Laver is very widely spread and grows in the Atlantic, Mediterranean, Indian and Pacific Oceans, Caribbean Sea and the Antarctic.

Purple laver contains many proteins and vitamins. As *nori*, it is incredibly popular. In Wales, *Porphyra purpurea* is cooked for hours and served as a laver bread at breakfast. In Cornwall it is sprinkled with vinegar and eaten cold. It is sometimes called 'Welsh caviar', 'black butter' or 'slake'.

Dulse

Palmaria palmata

Dillisk / Lappentang /
Goémon à vache

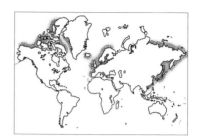

The flat leaves of dulse are shaped like the palm of a hand. They grow
directly from the holdfast, without a stipe, and divide into broad segments
that can be up to half a metre long. Dulse occurs in many colour variants,
from dark pink to reddish-purple, and has a leathery texture. Older plants
have new narrow leaves growing along the edges, especially where the
leaves are damaged. Young plants are less leathery and almost translucent.
Under water they appear purple.

In Scandinavia, dulse was used to treat infections, seasickness and
hangovers. For a few years now, it has been grown for consumption along
the European coast.

In the sixth century, the Irish monk Columba – who, stranded on
the island of Iona, built an abbey and brought Christianity to Europe –
proclaimed, 'Let me do my daily work, gathering dulse, catching fish, giving
food to the poor.' A thousand years later, in Iceland, dulse was on the daily
menu of pupils at the Latin (grammar) school. Dulse has a full, somewhat
smoky taste reminiscent of salty bacon or roasted hazelnuts.

The name 'dulse' comes from the Celtic word *dillisk*, which means 'leaf
from the water'. In *The War of the Worlds*, H.G. Wells was probably inspired
by dulse when he described an invasive, but unnamed, red seaweed that
the Martians brought with them when they attacked Earth. According to
Wells' story, Mars owes its red colour to this weed.

Common Coral Weed

Corallina officinalis

Korallenmoos / Koraalwier / Coralline

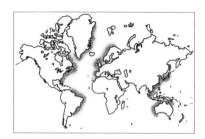

Common Coral Weed is a fern-like red seaweed. Calcium carbonate, produced in the cells, strengthens the thallus, making it truly harden and stand upright in the water. However, the individual segments are lime-free at the contact points, so that the seaweed remains mobile. Its reproductive organs are located at the tips of the fronds, which are often much lighter in colour and have more irregular contours. Once it breaks free of its substrate, the lilac weed fades, turns snow white and becomes brittle.

Coral Weed grows on rocks sheltered from the surf and can survive up to a depth of twenty metres along the northern Atlantic coast, from Norway to Morocco, from Greenland to Argentina, and in some parts of Japan, China and Australia.

The Flemish botanist and physician Rembert Dodoens wrote in his *Cruydeboeck* (1554): 'Coral weed has stony stems, as it had been given knees that are divided into thin snippets and almost hair-shaped side branches, that all grow out of a stony head. This plant is so hard that it seems to have the form and essence of a stone more than any herb.'

In the past, Coral Weed was used to treat parasites and worms, which explains the German name *Wurmmoos*. It is due to their calcium carbonate content that prehistoric seaweeds left fossilized imprints in rock. Examples have been found from the Jurassic, Cretaceous and Tertiary geological periods.

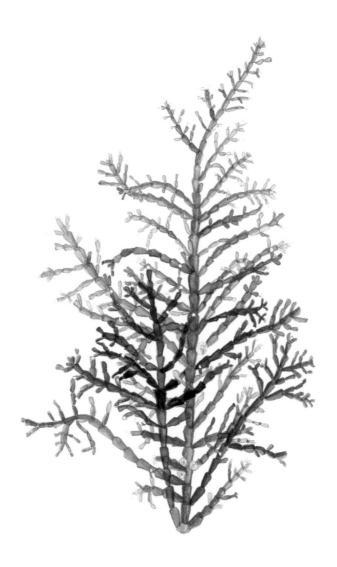

Irish moss

Chondrus crispus

Carrageen / Iers mos /
Knorpeltang / Goémon blanc

Irish moss forms shrub-like thalli that anchor themselves to hard surfaces with a disc-shaped holdfast. Several differently aged little shrubs grow from this point, each with a flat stipe that splits into between one and five fan-shaped branches. The texture of the thallus is pellicular to grooved.

Irish moss occurs in many varieties. It can be completely flat or crimped, just like parsley, and the colour is also variable, from dark red, to purple or maroon. In brightly sunlit spots, the weed bleaches to a yellowish-green. Young parts of the thallus are sometimes iridescent blue. The width of the frond tips varies between just a few millimetres to several centimetres, and they are usually square in shape. Each individual plant can grow up to twenty centimetres high. Irish moss forms large clusters and resembles miniature deciduous trees that have lost their leaves in the winter.

The English word *carrageenan* is a declension of the Irish word *carraigin*, which means 'small rock'. The perennial plant grows exuberantly on stones and rocks, in rockpools, in shallow waters around the islands of Ireland and Britain and along the entire European coast. It is rare in the Baltic Sea, but occurs in saltwater inland waters.

Irish moss is an important plant in the food industry because agar is extracted from it. In the past, beekeepers clarified their honey with it and beer brewers use it to make the undissolved parts of the brew sink to the bottom, as though it were a sieve.

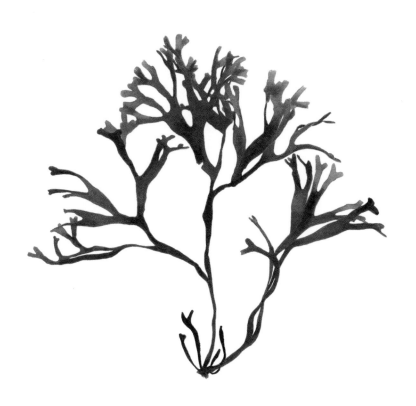

Bibliography

Rufius Festus Avienus *Ora maritima,* English translation, Chicago, 2003.

Cor Bruijn *Sil de Strandjutter,* Nijkerk, 1940.

Ann Christie *A Taste for Seaweed* in *Journal of Design History,* 24/4, S. 299–314. Oxford, 2011.

Adriaen Coenen *Het walvisboek,* Zutphen, 2003.

Alain Corbin *Le Territoire du vide. L'Occident et le désir du ravage,* Paris, 1988.

Johanna Catharina Daan *Wieringer land en leven in de taal,* Alphen aan den Rijn, 1950.

Roger Deakin *Waterlog: A Swimmer's Journey through Britain,* London, 1999.

Diverse Autoren *Het gevleugelde woord. De mooiste Japanse haiku's,* Part 1, Marke, 2013.

Florike Egmond *Het visboek,* Zutphen, 2005.

T. S. Eliot *Prufrock and Other Observations.* London, 1929.

Tristan Gooley *How to Read Water,* London, 2016.

Paddy Gregson *Ten Degrees Below Seaweed,* Braunton, 1993.

Rosemarie Honegger *Ein gebundenes Meeresalgenherbar von 1851 aus Basler Privat besitz,* in *Bauhinia* 26, 2016.

Alexander von Humboldt *Kosmos. Entwurf einer physischen Weltbeschreibung,* Stuttgart, 1845.

Elizabeth and Mary Kirby *The Sea and Its Wonders,* London, 1871.

Hans Kniep *Die Sexualität der niederen Pflanzen,* Jena, 1928.

Eberhard Kramm *Die Algen,* 2 volumes, Leipzig, 1952.

Hans P. Kraus *Sun Gardens, Victorian Photograms by Anna Atkins,* Oxford, 1985.

Dr Paul Kuckuck *Der Strandwanderer,* Munich, 1929.

Sonji Kurishita *Nori Farming for Human Consumption in the West Coast of Scotland,* Aberdeen, 2017.

Christopher S. Lobban *Seaweed Ecology and Physiology,* Cambridge, 1994.

Julia Lohmann *The Department of Seaweed: the Co-speculative Design in a Museum Residency*, PhD thesis, Royal College of Art, London, 2018.

Yann Martel *Life of Pi*, Canada, 2001.

Walter Migula *Kryptogamen-Flora von Deutschland*, Gera 1907.

Ole G. Mouritsen *Seaweeds: Edible, Available & Sustainable*, Chicago, 2013.

George Murray *An Introduction to the Study of Seaweeds*, London, 1895.

P. H. Nienhuis *Zeewieren*, Zeist, 1969.

Kaori O'Connor *Seaweed: A Global History*, London, 2017.

Akio Okazaki *Seaweeds and Their Uses in Japan*, Tokyo, 1971.

Dr W. P. Postma and H. Kleijn *Het strand in kleuren*, Amsterdam, 1957.

G. J. Resink *Kreeft en Steenbok*, Amsterdam, 1963.

Joanne K. Rowling *Harry Potter and the Goblet of Fire*, London, 2000.

Raoul Schrott *Erste Erde Epos*, Munich 2016.

H. Stegenga and I. Mol *Flora van de Nederlandse zeewieren*, Hoogwoud, 1983.

Sonia Surey-Gent and Gordon Morris *Seaweed*, London, 1987.

David Thomas *Seaweeds*, London, 2002.

William P. L. Thomson *Kelp Making in Orkney*, Stromness, 1983.

Jürgen Berndt *Rotes Laub: Altjapanische Lyrik*, Leipzig, 1972.

C. Wieche *Artic Seaweeds*, Vaduz, 2002.

Acknowledgements

With thanks to: Bettina Bach; Willem Brandenburg; Jozee Brouwer; Rachel Culver; John Day; Michel Dijkstra; Mark Ellingham; Wouter Engelbart; Rutger Emmelkamp; Menno Fitski; Jo Frenken; Kaori Flossmann; Professor Thomas Friedl; Kerry Fround; Judy & Giles Gibson; Keiko Harada; Kew Herbarium, London; Florian Hintermeier; Professor Irmela Hijiya-Kirschnereit; Nienke Hoogvliet; Michele Hutchison; Koninklijke Bibliotheek, Den Haag; Henry Iles; Bill Johncocks; Guillaume Kalb; Anna Krans; Luuk Langendijk; Christine Leach; Julia Lohmann; Dr. Dieter G. Müller; Dr Cait Murray-Green; Chasper Pult; Rijksherbarium, Leiden; Rijksmuseum, Amsterdam; Meike Rötzer; Daniël Rovers; Rob Sanders; Scottish Association for Marine Science, Dunstaffnage; Judith Schalansky; Family Van der Sluis; Konstanz city archives; Professor Dr Jürg Stöcklin; Kazufumi Suzuki; Nikky Twyman; Victoria and Albert Museum, London; Samuel Vriezen; Jos Vos; Lin Zwamborn-Klaassen.

Images

Every effort has been made to contact copyright holders of images reproduced in this book but if any have been missed please contact the publishers so that information can be corrected in future editions.

Grateful acknowledgment is made to the following copyright holders:

pp.22, 39, 50 © Collection Rijksmuseum, Amsterdam.

p.26 © Collection Koninklijke Bibliotheek, Den Haag.

pp.34, 35 © Collection Universitätsbibliothek, Basel.

p.49 © Julia Lohmann.

p.53 © Bridgeman Images/Museum of Fine Art, Boston.

p.57 Artworks by the artist © Succession H. Matisse / DACS 2020; Photo © Michel Sima / Bridgeman Images

p.60 © Maria Blaisse (*in collaboration with Karin Marseille*); photo by Anna Beeke.

p.62 © Ellsworth Kelly Foundation.

p.68 © Artokoloro/Alamy Stock Photo.

pp.74, 76 © Collection Victoria and Albert Museum, London.

p.98 © Collection SAMS Oban.

p.104 © Tove Jansson.

p.109 © Bridgeman Images/ British Library.

p.112 © Collection Zuiderzeemuseum Enkhuizen.

p.117 © Scottish Viewpoint/Alamy Images.

p.132 © Brian J. Skerry/Alamy Images.

p.20, pp. 135–148 (photos), pp.151–173 (watercolours) © Miek Zwamborn.

p192 Collection Ayumi Ellingham / Somerset & Wood Fine Art.

Notes

1 Dr Robert H. Fuson, *The Log of Christopher Columbus*, 1987, International Marine Publishing Company, Camden, Maine. Quoted in 'Christopher Columbus as a Botanist' by John M. Kingsbury (essay).

2 *www.strangehistory.net/2010/10/25/pytheas-and-the-mysterious-marine-lung/* Also: Fuhr, Maximilian, *Pytheas aus Massilia, historisch-kritische Abhandlung,* Darmstadt 1842, S. 15.

3 Avienus, Rufius Festus, *Ora maritima*, German translation, Darmstadt 1968.

4 Jean Rhys, *Wide Sargasso Sea,* Penguin Books, 1968, p.55

5 *https://ia802707.us.archive.org/22/items/travelsandreseaoohumbgoog/travelsandreseaoohumbgoog_djvu.txt* (English translation). Also: Alexander von Humboldt, *Kosmos. Entwurf einer physischen Weltbeschreibung,* Vol. 1, Stuttgart, 1845.

6 Adriaen Coenen, *Het walvischboek* [original manuscript], Koninklijke Bibiotheek, Den Haag.

7 After I'd found these prints, I asked Japanese specialist Jos Vos to translate the texts for me because I hoped they mentioned seaweed. Along with Kaori Flossmann, Keiko Harada and Kazufumi Suzuki, he managed to decipher these difficult ancient texts.

8 Maurice Rummens, Het rode kazuifel van Matisse *www. https://www.stedelijk.nl/nl/digdeeper/het-rode-kazuifel-van-matisse*, 1. 11. 2018.

9 Edwin A. Cranston, 'The Dark Path: Images of Longing in 'Japanese Love Poetry', Harvard Journal of Asiatic Studies, Vol. 35, 1975, p.95.

10 Roger Deakin, *Waterlog: A Swimmer's Journey through Britain*, page 131, Vintage Random House, 2000.

11 Ole G. Mouritsen, *Seaweeds, Edible, Available & Sustainable*, University of Chicago Press, 2013, page 2.

12 G. J. Resink, *Kreeft en Steenbok*, Van Oorschot, Amsterdam, 1963.

13 *www.andreasgreiner.com/works/from-strings-to-dinosaurs/*

14 Netherlands Ecological Institute (Nioo-knaw) 'Zeesla: massale groei van ›waterbrandnetel‹ opgehelderd' (Sea lettuce: massive growth of water nettles explained), online publication, 2000.

15 Tove Jansson, *Letters from Tove*, p.62, Sort Of Books, London, 2019.

16 Ann MacKenzie, *Island Voices: Traditions of North Mull*, Birlinn, Scotland, 2002.

17 Johanna Catharina Daan, *Land en leven in de taal*, Alphen 1950. p.140.

18 Cor Bruijn: *Sil de Strandjutter*, Nijkerk 1940. Pages 57-66.

19 Ben Smith, *Eat Like a Fish: My Adventures as a Fisherman Turned Restorative Ocean Farmer*, Alfred A. Knopf, New York, 2019, p.178.

20 Quoted in *Eat Like a Fsh*, p.11.

21 Quoted in *Eat Like a Fsh*, p.9.

22 *www.Greenwave.org*

23 *https://haikuoftheforest.wordpress.com/2014/08/13/matsuo-basho-selected-haiku/* Also: Bashō, *The Complete Haiku* (translated by Jane Reichhold), Kodansha International, Japan, 2008.

24 Quoted in *Eat Like a Fsh*, p.137.

25 *Life of Pi*, p.253, *Life of Pi*, Knopf, Canada, 2001.

26 *Harry Potter and the Goblet of Fire*, p.426, Bloomsbury, London, 2000.

Index

Note: Italic page references indicate a relevant illustration.

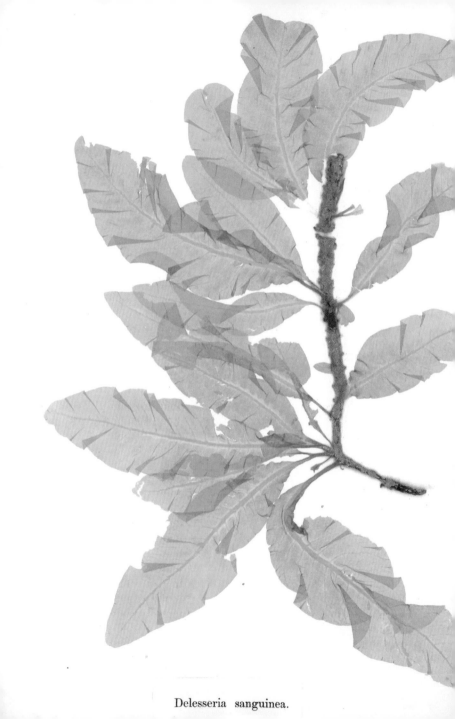

Delesseria sanguinea.